STEAM TODAY

BRITAIN'S HERITAGE RAILWAYS IN PHOTOGRAPHS

GEOFF SWAINE

The History Press

First published 2016

The History Press
The Mill, Brimscombe Port
Stroud, Gloucestershire, GL5 2QG
www.thehistorypress.co.uk

British Library Cataloguing in Publication Data.
A catalogue record for this book is available from the British Library.

ISBN 978 0 7509 6634 4

Typesetting and origination by The History Press
Printed in India by Replika Press Pvt. Ltd.

CONTENTS

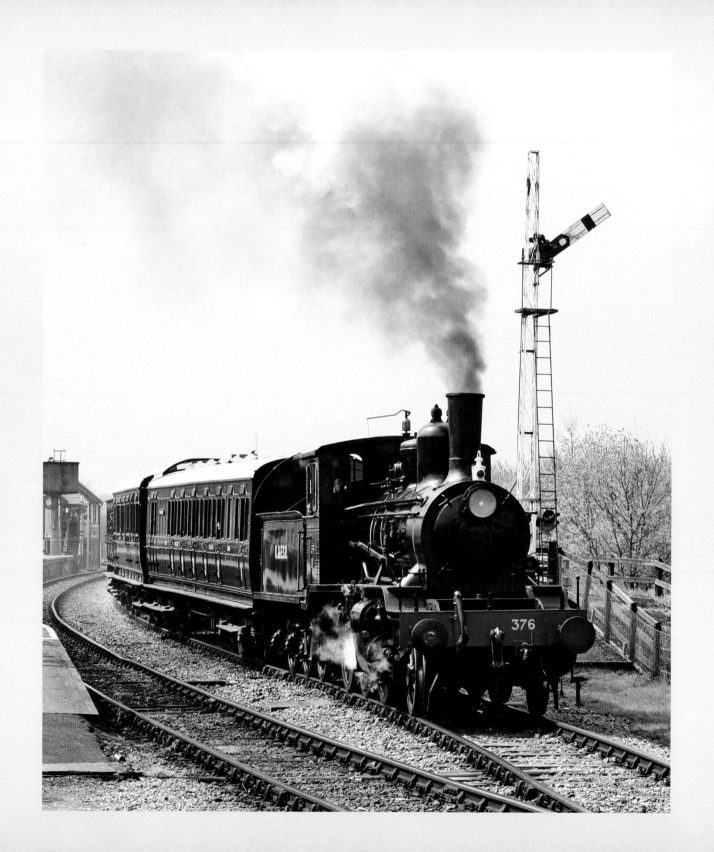

INTRODUCTION

The preservation movement, which stood alone to save steam from destruction in this country, is now at the height of its powers and uses great imagination to put on special events. We can now appreciate these events through the pages of this book and stand in awe at the sheer theatre that surrounds all the activities available at the various rail centres throughout the UK.

The generation who started it all are now passing it over to the next set of people who are similarly enthralled by being a part of Britain's industrial heritage. A new revolution has happened to allow Britain to pioneer the saving and revival of a mode of transport that was deemed obsolete. The haste in which steam was removed from the railways did, in fact, enliven the spirit of those people who would not let it just die.

These people follow on from those of the Industrial Revolution during which Britain led the way in new technology. Coal and coke took over from charcoal to fire boilers with much more heat. It was Richard Trevithick in Cornwall who first realised that higher pressure steam was a possibility to take the steam engine from being a static device to something powering a moving locomotive running on rails. Through the 1700s steam engines were available to pump water out of deep mines, but for the century after that, everything was on the move. The early years of the nineteenth century saw pioneers attempt to develop Trevithick's ideas and improve on efficiency of the steam locomotive, to be able to pull coal wagons along tracks and relieve horses of this burden. George Stephenson was the leader in this field and was followed by his son, Robert.

In 1829 the famous Rainhill Trials were held where various steam-driven engines attempted to take a train between Manchester and Liverpool. Robert Stephenson's *Rocket* was the clear winner and his engine was responsible for pioneering the new technology. Two years later the locomotive *Planet* proved superior and was well suited to haul passenger traffic. These engines were instrumental in the Victorian desire to cover the country in the new transport system.

Not only was it necessary to develop the engine's rolling stock, but the track had to be developed also. It can be imagined how the Victorians had to invent and get their heads around the intricacies of point-work. As well as this, safety measures had to be improved, not only for the track, but for the boilers too. All through those early years, drivers and firemen were losing their lives to exploding boilers. The development of the railways was not harmonious and it was certainly not plain sailing.

There is a sense of awe one feels when looking at a map of Britain's railways around the 1940s – the sheer complexity of the system and the amount of work that went into making it. We know that a lot of the services had been duplicated because of the rivalry between private business operations in the mid 1800s. But that turned out to be a bonus during the war when so much freight needed to be carried and, if a line was bombed, there was usually a nearby alternative that could be used.

Nowadays, with the steam railways solely being for leisure, we can appreciate the railways as part of the country's heritage. Sleepy towns and villages get swept along by the tide of it all. Whole areas where the preserved railways run their tracks have been revitalised into major tourist locations, attracting people with money to spend into the heart of the community.

One of the reasons why the railways and their artefacts are so popular is the desire of the preservationists to maintain the traditions and authenticity. Those engines should run just as they were built to: powered by coal and

in period liveries. Yes, sometimes the bounds of authenticity have to be stretched, but this is often dictated by the stock that has been inherited. If an engine has a double chimney, which was the result of a later development to provide better steaming, it can't then be expected to revert back to how it was just to be absolutely authentic to an earlier age. Great efforts are made to recreate the past and how we all love to see those engines portraying the colours of a variety of eras.

All skills are needed in the maintenance of the heritage centres. These range from the platform caterers through to upholsterers and painting specialists and, of course, the engineers with the skills to maintain those steam monsters in running condition. We also have the firelighters and crews who spend long hours before and after any travelling is done in preparation work. The signalmen and level-crossing keepers have a solitary day keeping the lines clear for operation. We must not forget the people who keep the vegetation under control along all those country miles of trackwork – another great contribution. And there are all those other great people, mostly doing it for

nothing, who proudly wear a uniform of the railway. Through the pages of this book, we can see how the general public have become enthralled with the sights, sounds and smells that engulf the live steam centres. The steam engines are possibly the nearest any machine can be to a human being. All the sighs and groans are there together with the outpouring of satisfaction when all is going well. For those people who rescued a rusting hulk from Dai Woodham's scrapyard at Barry Island, South Wales, we can appreciate the part they have played in Britain's industrial history. As we have documented in the following pages, 213 rotting locomotives came back from the brink this way to enable the steam preservation movement to become part of history. So many of the engines shown in these pages have come back to life from scrap condition, having taken years of work by dedicated people.

The subject of this book may be steam today, but it is also a celebration of what the steam preservation movement has become in the second decade of the twenty-first century. It reminds us of the history of the steam railway, leading us to where we are today.

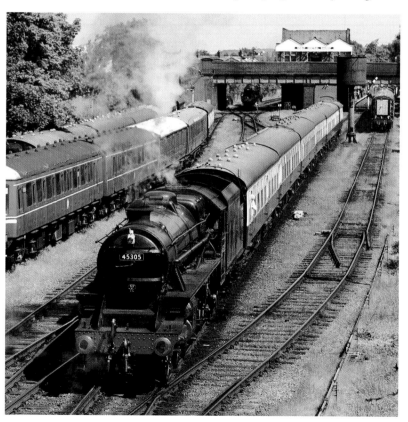

A southbound service leaves Loughborough Central station with LMS Black Five 4-6-0 No. 45305 at the head. The train gathers speed for the run down the Great Central Railway main line.

HAWORTH CELEBRATES THE FORTIES

Through the 1940s

he war years were some of the most significant in the history of the railways. The staff that manned the railways played a huge role in providing transport in those horrible years. Without that contribution those conflicts would have been lost. We all know about the men working shifts, which went on all day and night, the coping with hostile aircraft, the falling bombs and the signalmen who would not leave their posts in an air raid – not forgetting the ladies who filled the roles left by men who had departed or been lost to war. Without these people the railways could not have provided the service the country needed. We also remember the ladies who manned and served the canteens and buffets to provide a free meal to anyone in uniform in the darkest of times.

It is, then, not surprising that the preservation movement likes to honour those times in thanks to the people who got us through – on the railways and off. War recreation events and 1940s celebrations are now leading activities in our rail centres. The spirit, humour and skill all shows through from the re-enactors to all those people who have spent masses of their spare time restoring old vehicles or pieces of equipment – all to add it to the nation's historical archive. The traders also serve a vital role by providing an outlet for all the bits and pieces, which people need and collect. It can be particularly nice to have a cup of tea out of a tin mug.

As we know, Britain won the war but at a significant cost. With the end of the lend-lease agreement from America, the country went into a decade of austerity. At our re-enactment events we display examples from the clothing of the time and have kitchens without any mod cons. In spite of the struggle, the people came through. War babies and baby boomers are now grown up and getting old. Without a war victory there would have been a police state. No freedom, no free speech and little joy in life. So it seems right that we celebrate those past times and enjoy them.

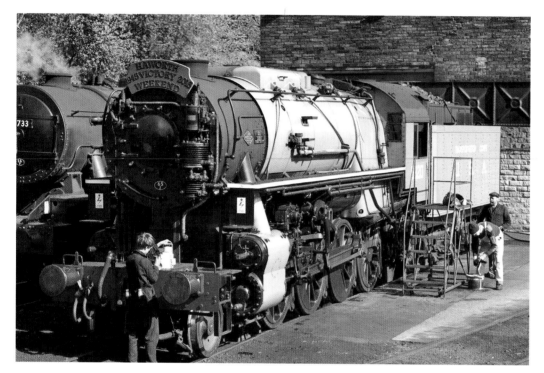

Standing alongside its companion for the day WD No. 90733, the S160 proudly displays the headboard carried for the occasion. Both engines are truly worthy to be the stars of the Keighley & Worth Valley's 1940s Weekend, both having been constructed for the war effort. In the background is the railway workshop.

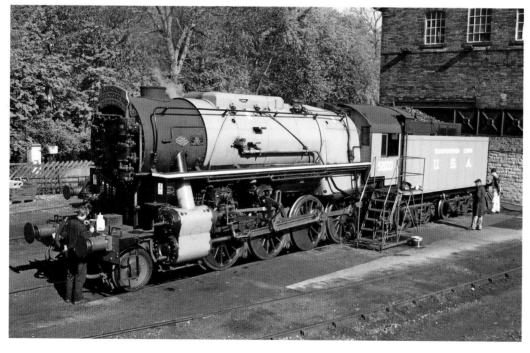

USA Transportation Corps S160 2-8-0 No. 5820 *Big Jim* is prepared in the early morning sunshine for the Keighley & Worth Valley's 1940s Weekend. The event commemorated the anniversary of seventy years since VE Day. Haworth is the headquarters of the railway and the town has a yearly event to take itself back to the forties to celebrate the period.

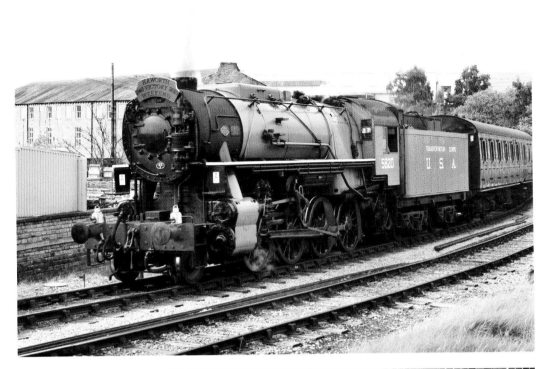

The second service of the day takes the curve outside Keighley headed by *Big Jim* No. 5820. After twenty years out of service, the K&WVRs own *Big Jim* American S160 No. 5820 came back in traffic to run at the Worth Valley. Here the US war engine brings its train around from Keighley station to begin the climb to Oxenhope. The railway climbs for the whole of its length – 330ft.

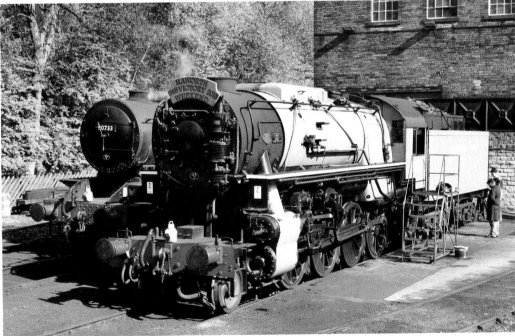

This festival of the 1940s provided the chance to see together two 2-8-0 engines produced for the war: WD No. 90733 and S160 No. 5820. The USA Transportation Corps S160 is carrying its authentic USATC grey livery.

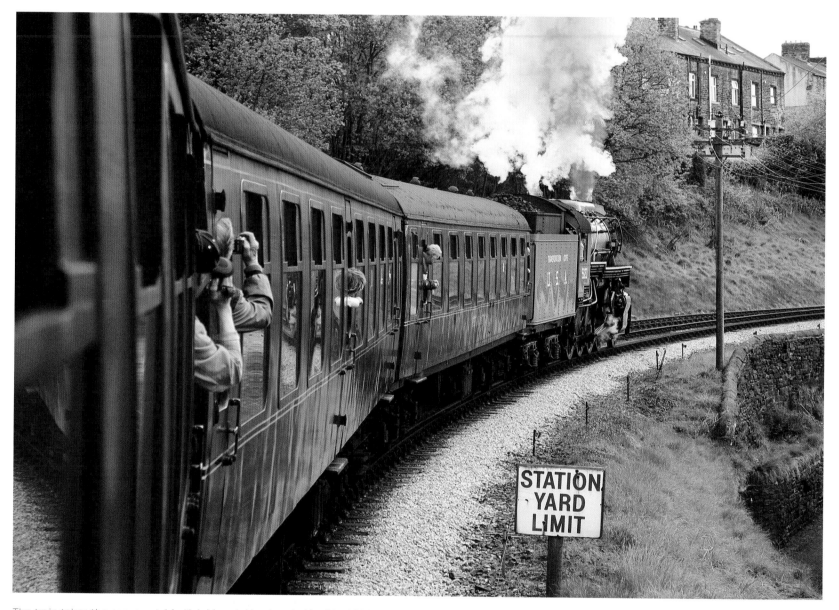

The train takes the curve outside Keighley station headed by No. 5820, which arrived in the UK in 1977. No. 5820 was built in 1945 by Lima of Ohio in the USA for the US Army to aid the war effort in Europe. Purchased by the railway, No. 5820 finally arrived at Haworth in November 1977 to be returned to service in February 2014, temporarily painted in British Railways unlined black.

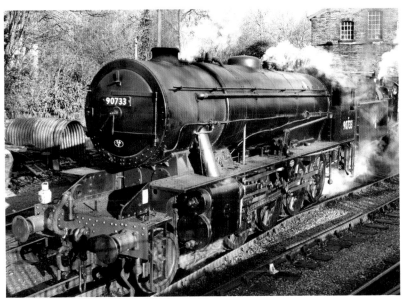

Austerity locomotive WD No. 90733 is showing the wartime livery of unlined matt black. It was built in January 1945 by the Vulcan Foundry Ltd for shipping to the continent. Later, after being in the ownership of the Swedish State Railways, it was purchased by the Worth Valley Railway to arrive back in the UK on 12 January 1973. After a heavy repair which began in 1993, the engine was rebuilt to its original form. There is a public viewing area, too, on the right of this picture – a good location to catch the early morning sunshine.

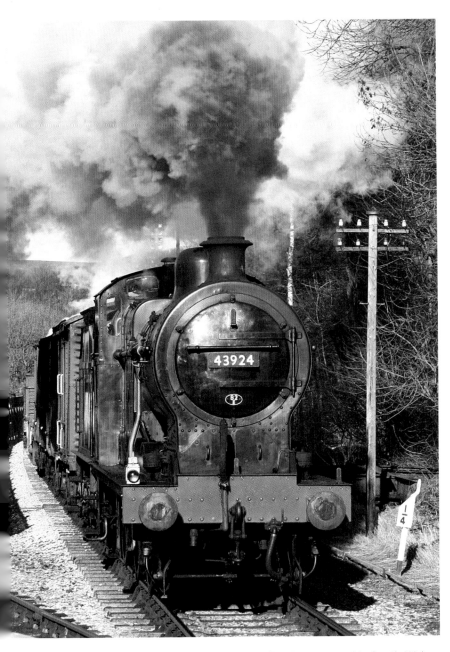

The first locomotive to be saved from Woodham's scrapyard in South Wales, No. 43924 arriving at Haworth in the summer of 1970. LMS workhorse 4F 0-6-0 No. 43924 was built in 1920. The Midland Railway Fowler 0-6-0 catches the sun on the approach to Ingrow station. The class became a mainstay of the LMS after the 'grouping'.

The Riddles-designed wartime WD Class. The 2-8-0-wheel arrangement was the preferred general-purpose set-up to haul goods traffic in wartime. This loco was the only one of this wartime class to be saved, the class having been thought mundane and not worthy of preservation by the authorities at the end of steam in Britain.

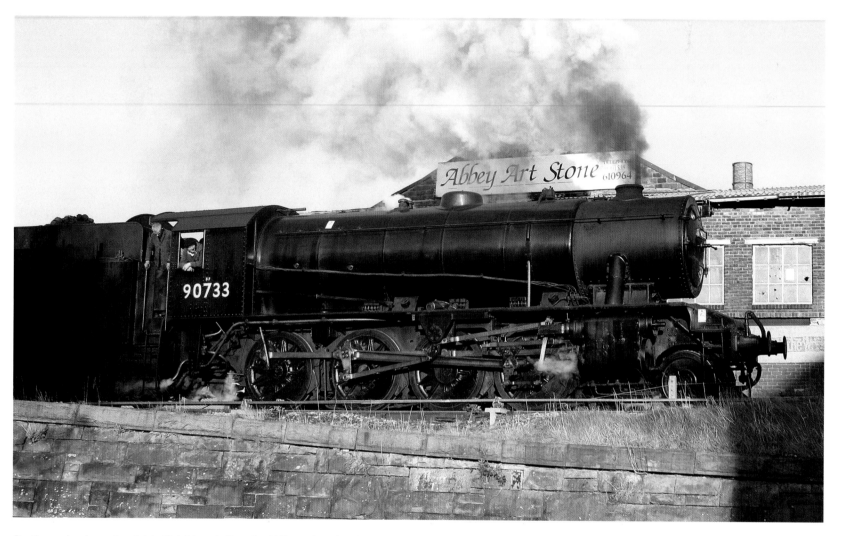

On the embankment outside Keighley station, the WD engine changes track to begin another journey up the incline. The loco, of which this one is now unique, re-entered traffic on Monday 23 July 2007 to be numbered as BR 90733. The engine here will shortly be moving off on to the running line to reverse into Keighley station to begin the activity of the day.

Part of the Haworth annual celebration of the 1940s when the railway and town transform and take themselves back to that period.

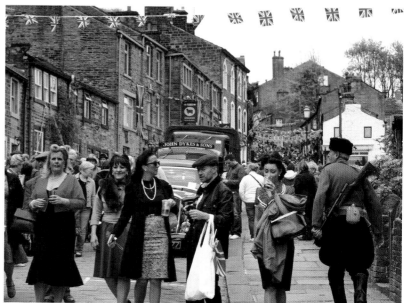

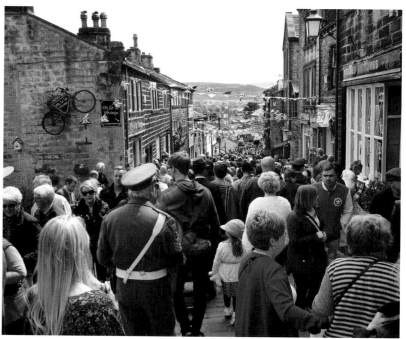

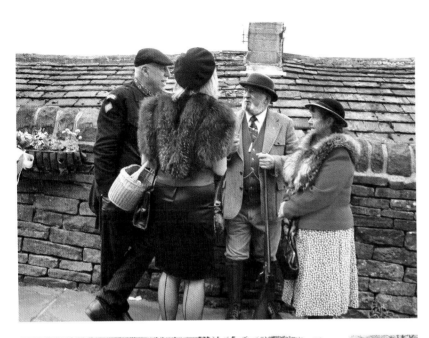

TWO

SUBURBAN AND BRANCH LINE

London Suburban

The mid-range engines are the workhorses, with a wheel arrangement of 0-6-0 and inside cylinders being the standard that all railways used. Tank engines, which could operate easily facing both forwards and in reverse, became the norm. 0-6-0 engines with tenders gave just that bit more route accessibility.

Nowhere through the days of steam has there been more diversity in the use of small locomotion than in the London suburban services. All four regions diverged here. The lines radiated out with services short, medium and long to be dealt with. From our point of view of rail preservation, the services from the south side of London are perhaps most interesting to enthusiasts today. There is an abundance of early engines still with us from this region, with some showing liveries and names from early times. For example, William Stroudley left us the Terriers, those diminutive locos with a big heart. They were operated by the London & South Eastern Railway (L&SER) company for use in London from 1872.

The names *Fenchurch* and *Stepney* of the two examples at the Bluebell Railway leave us with no doubt as to where they plied their trade. They operated manfully until the size of commuter trains grew enough for slightly larger examples to take over, such as the P Class. Later the even bigger Dugald Drummond M7s and the E4s came in. Examples of the Beattie well tanks have survived due to them spending seventy years serving the china clay industry in Cornwall. They too operated around the London suburbs for the London & South Western Railway (L&SWR) in the late 1800s before they were replaced.

For the Eastern Region, the N2s came out of the Metropolitan Railway tunnels into the cauldron of steam at King's Cross station. That smoky climb through the hotel curve must have ranked with the Templecombe tunnel near Bath as the most dreaded steam climb in England. The N2s hauled all the suburban serves from King's Cross, at the time, to Hatfield and Hertford. The Quadart sets of carriages looked quite different then to those now running on the North Norfolk Railway. Liverpool Street station had the similar sized N7s, which had to be powerful enough to cope with the tricky 1 in 70 climb out of that station.

The Midland Region preferred the larger tanks such as the Stanier, Fairburn and Ivatt types for their short- to medium-range services. The swansong of steam on the former London Tilbury and Southend system was something to behold for the lovers of good grime and raw steam.

The Great Western Railway (GWR) survived through all the good and bad times, only to succumb to nationalisation in 1948. Swindon built its classes to have its distinctive look with its interchangeable parts being prominent. The evolution of its engine design for the high-capacity suburban services out of Paddington station culminated with the large Prairie tank (2-6-2T wheel formation). These had to be fast off the mark with the strength to get up and down the Westbourne Park underpass and away. The last batch of these had a higher boiler pressure and the 5ft 8in driving wheels were a foot wider than the 'Small Prairies' of similar design.

In the 1960s, surplus WR Pannier tanks were sold to London Transport for use in and around the Metropolitan Railway. Here engine 57XX Class 0-6-0PT No. 5786 (L92) represents that period in railway history at Buckfastleigh on the South Devon Railway. On loan from the Severn Valley Railway, L92 was purchased direct from London Transport in 1969 to be one of that railway's earliest resident locos.

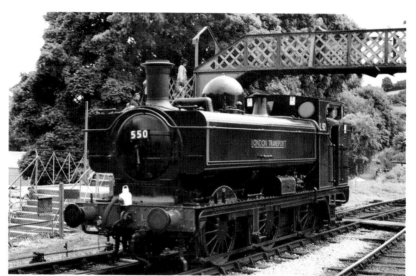

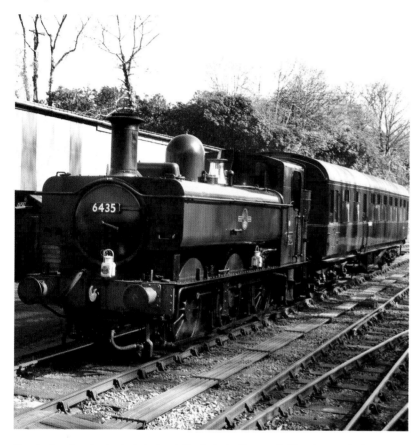

Example of a single Autotrain at Bodmin in Cornwall. The Autotrain is headed by Pannier tank 6400 Class No. 6435, waiting its turn of duty.

Further down the line from Buckfastleigh, Pannier tank L92 follows the River Dart approaching Staverton. The South Devon Railway Pannier tank engine is resplendent with paintwork reflecting in the river. Quite unlike the old life in times gone by.

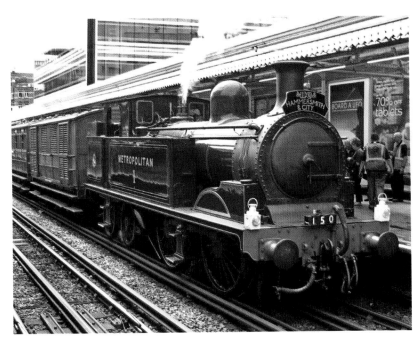

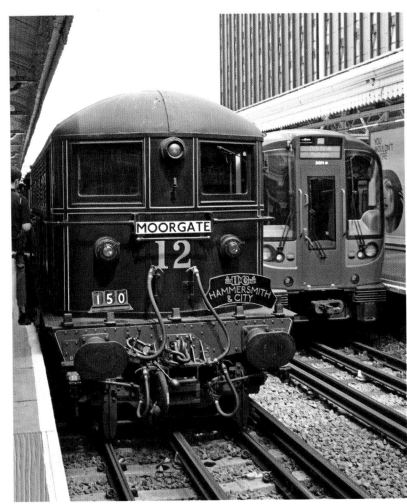

A Metropolitan Steam Weekend festival was held in 2014 to celebrate the 150th anniversary of the opening of the Hammersmith and City extension of the Metropolitan Railway in 1864. Metropolitan Locomotive No. 1, 0-4-4T led the way as seen at Hammersmith station in London, supported by Metropolitan electric locomotive No. 12 *Sarah Siddons*. The coaching stock is the Chesham set from the Bluebell Railway, together with the Milk Van No. 3 from 1896.

Metropolitan electric locomotive No. 12 *Sarah Siddons* has brought the train through from Moorgate in commemoration of the 150th anniversary of the opening of the line. These powerful electric locomotives ran between 1923 and 1962 on the Metropolitan Railway.

Small Prairie tank engine 2-6-2T No. 5521 has been brought in to assist with celebratory steam runs on London's Metropolitan Railway. This day it is running as L150, taking a train out of Rickmansworth station for Chesham. The WR engine was called in as the second steam engine for a special two-day running commemorating the 125th anniversary of the opening of the Chesham branch line.

The Autotrain makes a splendid sight on the Llangollen Railway having just left Glyndyfrdwy and heading up-grade towards Berwyn tunnel.

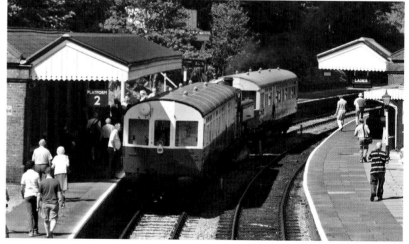

The driver of the Autotrain clangs as he is in the vestibule at the head of the train. The train is on the severe gradient of the Berwyn bank on the Llangollen Railway. In this formation, with the loco in the middle, the Autotrain has the ability to carry four coaches maximum. The driver controls the regulator in the engine by means of rods carried below the train. The maximum range of these rods is usually two carriages.

The train is halfway up the platform owing to its formation as a push-pull unit. A great view of Llangollen station from the medieval bridge across the River Dee. As the engine is in the middle of the set it cannot get water from the end of a platform. A special watering point has been installed halfway up the platform to suit this train. The engine has the Western Region express livery of lined Brunswick green. Various classes of non-passenger locos did appear like this in the late 1905s.

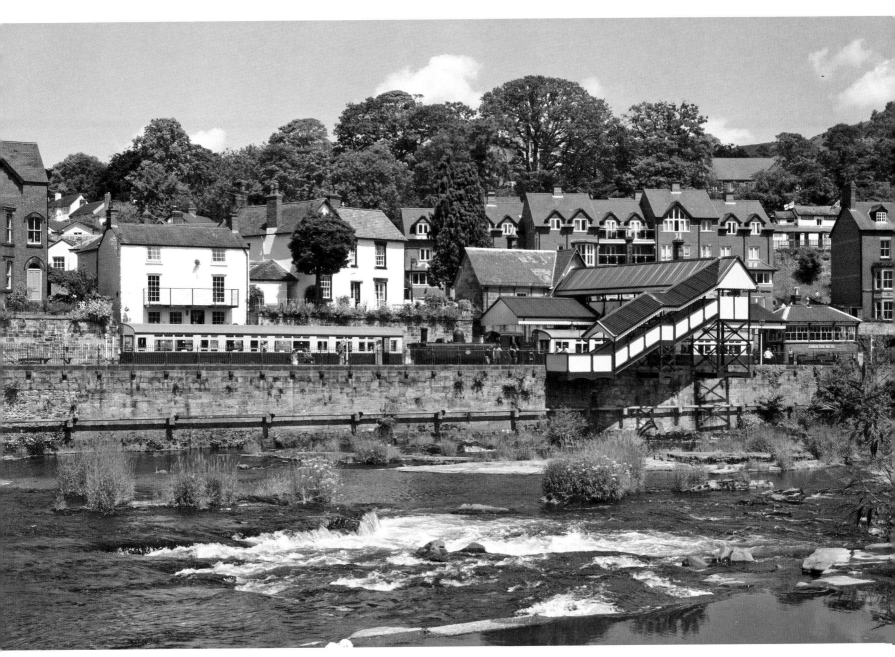

Llangollen station as seen from across the Dee. The space in the station is so restricted that the footbridge has to hang out over the river. The Autotrain waits in the station.

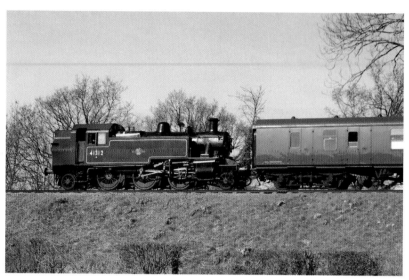

LMS design Ivatt 2-6-2T No. 41312 heads a westbound train towards Ropley on the Mid Hants Railway. This style of large tank engine was originated in the late 1920s by Fowler, to be perpetuated by just about every Chief Mechanical Engineer afterwards.

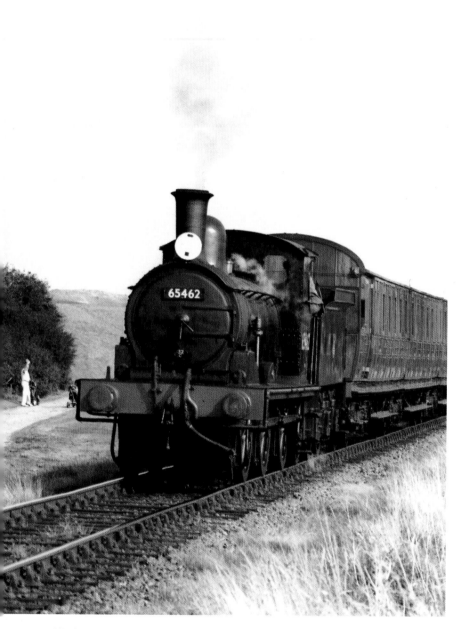

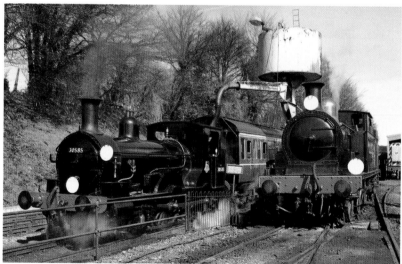

Climbing the Sheringham bank on the North Norfolk Railway is the inside-cylindered Worsdell Y14 Class (LNER J15). The engine was built at Stratford in 1912 and carried numbers LNER 7564 and BR 65462 before withdrawal in 1962.

Metropolitan Railway No. 1 together with Beattie Well No. 30585 tank stand beside the watering point at Ropley. No. 1 worked the last steam-hauled service on the Chesham branch in 1960, and the last service between Rickmansworth and Amersham in 1961.

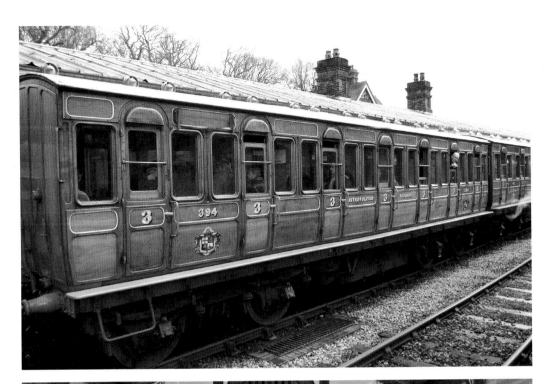

Metropolitan full third carriage from 1900. Now part of the Chesham vehicle set at the Bluebell Railway. This and the three other examples ran the Chesham branch after 1940 and were part of the 125th anniversary celebrations.

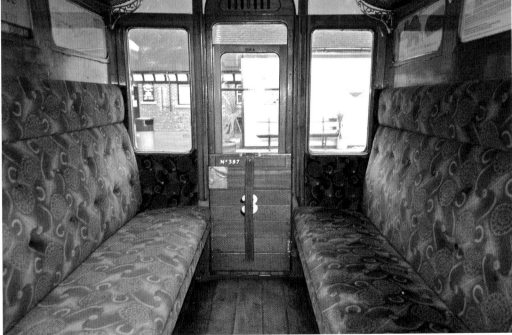

The very tight interior of a compartment of a Metropolitan Railway carriage. Not much leg room for the seven-a-side passengers. Add to that two or three standing and perhaps smoking. Commuting was not something to behold through most of the twentieth century.

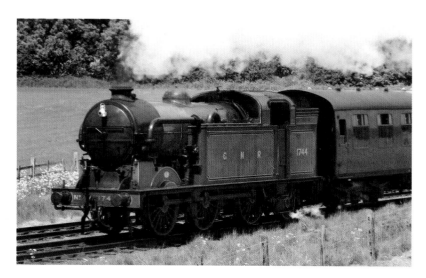

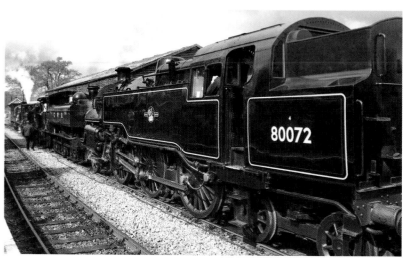

Visiting engine N2 0-6-0T No. 1744 on the southerly Great Central Railway approach to Quorn and Woodhouse. The engine is in the green livery in which it entered service for the Great Northern Railway in 1921. These engines worked through the tunnels of the Metropolitan Railway and performed carriage movement and short-hauled passenger work from London's King's Cross station.

British Standard 4 tank engine 2-6-4T No. 80072 is a visitor to the Weald of Kent and is part of a cavalcade at the Kent & East Sussex Railway. On loan from the Llangollen Railway, the engine formerly plied its trade in less glamorous surroundings, working the suburban services out of Fenchurch Street station, London.

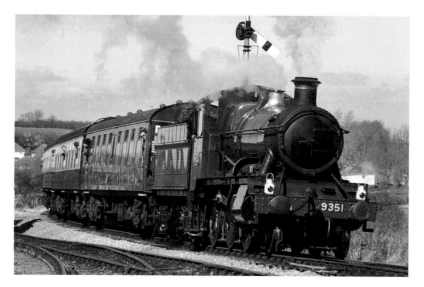

Mixed-traffic engine 2-6-0 No. 9351 heads a train towards Williton on the West Somerset Railway. An engine newly built in preservation, contrived with parts from the donor tank engine, GWR Prairie No. 5193. The home signal gives clearance for the train to enter Williton station from the west.

THREE

THOSE EARLY DAYS

Railways had existed in Britain before 1800, but these were horse-drawn affairs pulling small mineral wagons. The breakthrough, though, was to happen in the first decades of the nineteenth century.

Steam engines existed in mines to pump out water, and also extracted the ore and lifted men in cages up and down the shafts. Steam power was a revolution in allowing mines to be bored much deeper and therefore be more profitable. Engines powered by steam also pulled some trucks on the surface by cable before the breakthrough, which was to use the steam engine as a moving power unit running on rails.

This innovation came via Richard Trevithick, the son of a Cornish mine engineer, whose inventive mind led him to believe that a steam engine could be developed to be portable. The static pumps in existence worked on low-pressure steam, whereas Trevithick realised that it would take a much higher pressure to obtain the power needed from a smaller power unit. In the first instance, he developed an engine to run along roads in 1801. Taking things further, he then came up with a steam car, which ran on a pressure of 30P.S.I. It worked, but was so unstable that he realised the answer was to run his machine along a track. Finally, in 1804, he was successful and thereby became the inventor of the steam locomotive.

A drawback of this first system was that the weight of the locomotive constantly damaged the cast-iron rails on which it ran – a problem that was not wholly solved until George Stephenson of Newcastle developed wrought-iron rails. He also made the next significant breakthrough by sending his engine *Locomotion No. 1* to Darlington in 1825, where it hauled a train of thirty-eight wagons from Shildon to Darlington and then on to Stockton at an average speed of 12mph – the first successful goods locomotive

transit. It was down to Stephenson's son Robert, however, to make the next breakthrough by producing *Rocket*, the engine that transformed steam power on rails.

Authorities wanted confirmation on which engine amongst the variations being developed would be worthy of use on the newly built line between Manchester and Liverpool. In 1829 the Rainhill Trials were set up. *Rocket*, with its pistons at an angle, easily won this event. The development of a tubed boiler gave all the power necessary and the train travelled at the commendable speed of 24mph. In other trials the locomotive reached over 30mph, making it the fastest ever man-made machine of the time.

Whilst *Rocket* had successfully hauled goods along lines, it was soon to be overtaken by *Planet*, in 1830, which was better equipped to work passenger trains. With the introduction of a frame and better working conditions for the crew, the engine became the prototype upon which all new designs were based. Within a couple of decades, railway lines traversed the country to become the preferred mode of transport and, thus, a revolution was under way.

Progress during the Victorian era was so rapid that by the end of the nineteenth century companies were racing against each other for dominance. Private practice was the way of the world with rival companies competing against one another. Unlike most other countries, where the governments would set up and build the system, Britain went haywire and permitted more than one operator to build and offer to the public a route largely covering the same ground as someone else. Most large towns had different rail companies serving them (Chester had four).

It was all pioneering, innovative stuff, with the public really taking to the new form of transport. Excursions could be made which took people away

from their home towns for the first time. Trips to the coast became hugely popular, in particular, which in turn led to those coastal places becoming resorts. The Great Exhibition of 1851 saw a huge number of passengers make day excursions to Crystal Palace, in Hyde Park.

Natural advances in the safety surrounding the running of a locomotive followed the evolution, as did the safety aspect of signalling and point-work. Style and pride led the way into the Edwardian era, which brought careers and full-time employment for life.

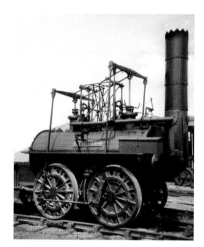

Left: Whilst Trevithick's *Catch Me Who Can* might not have been a huge success, it set the style for other inventors to emulate through the early 1800s. By 1825 Robert Stephenson had produced the celebrated *Locomotion No. 1*, which ran on the innovative Stockton and Darlington line. The similarities with this replica show just how important Trevithick's work was in the development of the steam engine.

Below left: Richard Trevithick broke new ground with the loco *Catch Me Who Can*. In 1808 he had the loco built by the Hazeldine Foundry of Bridgnorth. Now, 200 years later, some local enthusiasts have had this replica built to celebrate the event, where it is now on show. The original was the first engine to pull fare-paying passengers, which it did on a circular track in London, but unfortunately it broke the cast-iron rails.

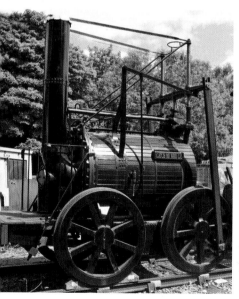

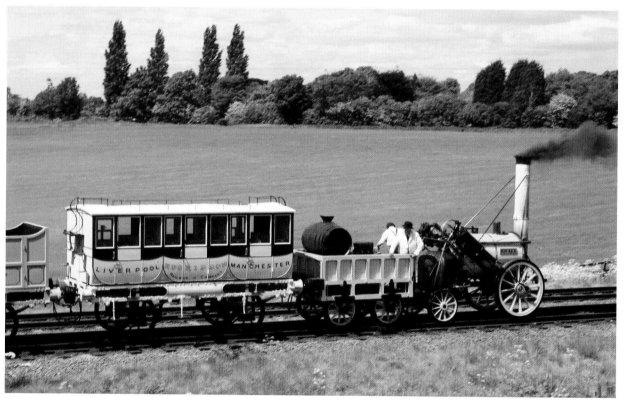

Above and opposite top: Replica *Rocket* heads towards Quorn on the Great Central Railway. Note the style of the early carriage – the carriage makers just placed stagecoach-style units on to a frame. The frame would have been that of an existing goods wagon.

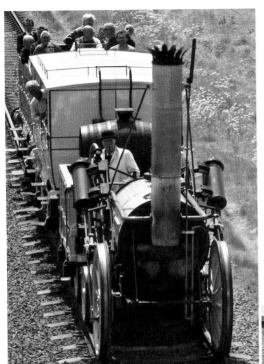

The Manchester Museum of Science replica engine *Planet* has a rare outing to another railway. Here it is at the Great Central Railway in Leicestershire. The original *Planet* was built by Robert Stephenson in 1830 for service on the Manchester–Liverpool line, being the first ever dedicated engine for passenger traffic.

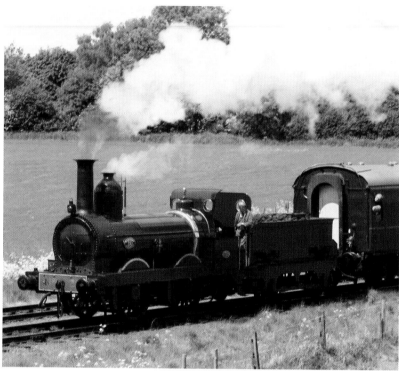

Furness No. 20 heads southward along the racing stretch of the Great Central Railway.

Furness No. 20: Britain's oldest working standard-gauge engine, proudly wearing the Furness Indian red livery. It was restored to working life in 1999 by the Furness Railway Trust, Barrow.

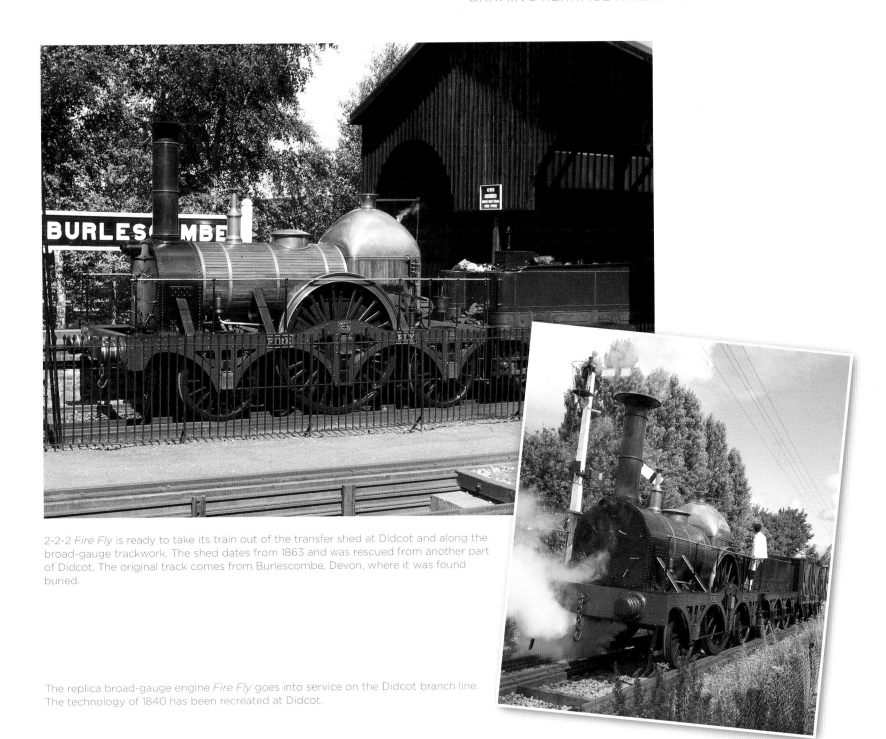

2-2-2 *Fire Fly* is ready to take its train out of the transfer shed at Didcot and along the broad-gauge trackwork. The shed dates from 1863 and was rescued from another part of Didcot. The original track comes from Burlescombe, Devon, where it was found buried.

The replica broad-gauge engine *Fire Fly* goes into service on the Didcot branch line. The technology of 1840 has been recreated at Didcot.

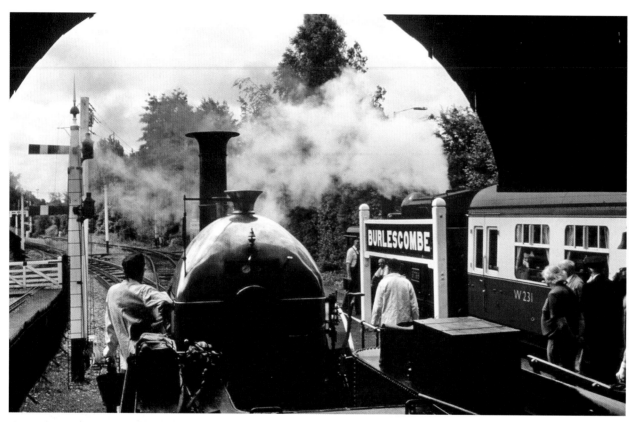

View from inside the transfer shed where *Fire Fly* occupies the larger side. Goods would be transferred from a train of one gauge to another, but today it is all about preserving the industrial past and making it a pleasure for visitors to learn about it.

Broad gauge and standard gauge come together at these points, which makes for a rather interesting study in dual-gauged point-work. The transfer shed is in the background where goods would be transferred from one gauge to the other.

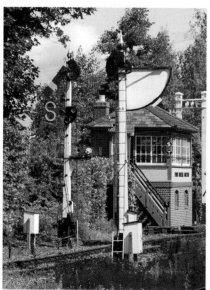

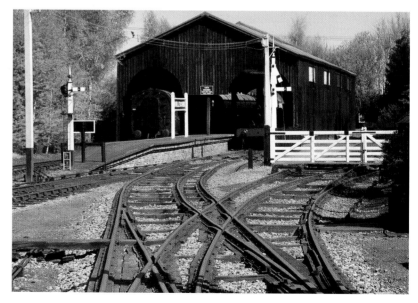

Signalling from all ages is represented at the Didcot Railway Centre. Here all are controlled from the former Frome Mineral Junction signal box. Note the overhead wires.

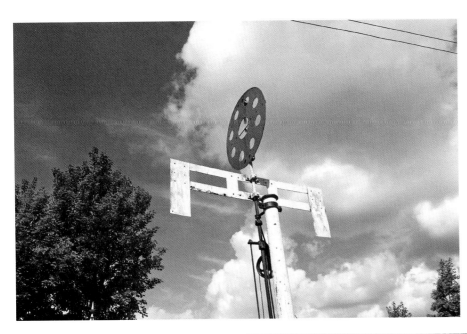

Broad-gauge disc and crossbar signalling. The downturned ends of the crossbar dates this example to after 1852. They would be operated by overhead wires, whereas in the early days each signal would be manned. A signalman would wait six minutes before allowing another train through.

As a reminder that rail technology in the nineteenth century was a very hazardous business. The graves of two rail men are side by side in the churchyard at Bromsgrove. Both men died as a result of boiler explosions within two days of each other in 1840.

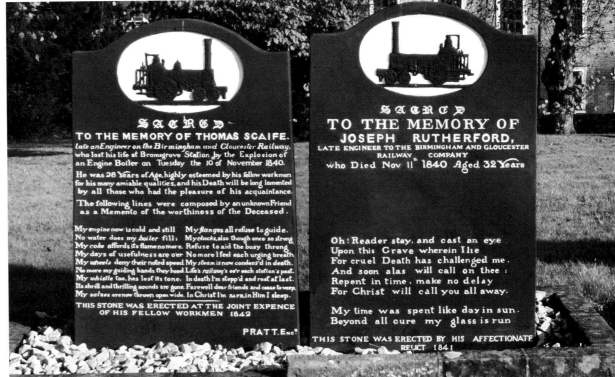

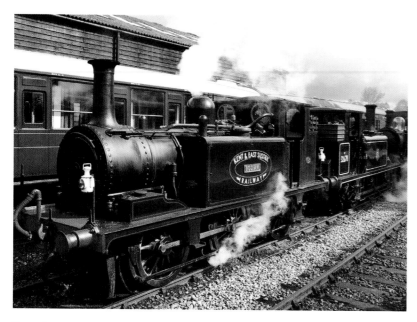

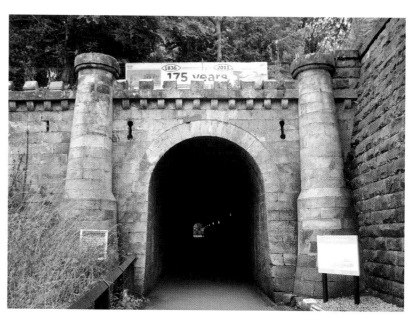

Two classic Terriers buffer up at Tenterden. No. 3 *Bodiam* and sister engine No. 8 (32678) *Knowle*. All the terriers originally worked the tunnels of London – hence their original names – before being superseded by larger tank engines such as the E4 and M7 classes. No. 3 (originally named *Wapping*) also worked the Hayling Island branch, whilst *Knowle* has also been active on the Isle of Wight.

George Stephenson's original tunnel of 1836 at Grosmont built for horse-drawn trains. This was superseded by the nearby 'Big Tunnel' when steam took over. Stephenson had fun with this tunnel front, making it look like part of a fortified castle. The style did catch on, however, as it was copied by railway designers all across the country.

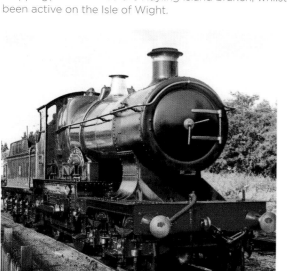

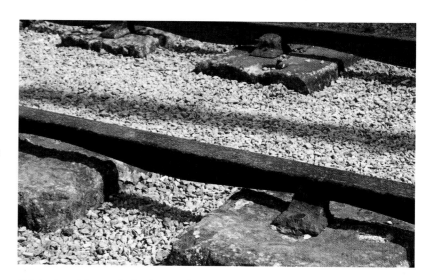

In all its pomp and glory *City of Truro*, the engine that first claimed reaching the speed of 100mph, is returning to the shed at Toddington on the Gloucestershire Warwickshire Railway. The Dean pattern outside frame, coupling rod crank and outside-framed bogie firmly places this design in the Victorian age. G.J. Churchward added to the Dean design with a tapered boiler, but he was soon to favour six coupled driving-wheel sets.

Original cast-iron rails for horse-drawn trains. Surviving sections of cast-iron fish-bellied rails from the days of George Stephenson on display at Pickering station. The horses would walk between the concrete-block bases.

FOUR

THE SOUTH AND WEST

Chief Mechanical Engineers

The Chief Mechanical Engineer of a railway company was the top man in charge of locomotives and rolling stock. He was a man right at the top of his game, having come through the ranks, learning from those around him, and aware of what was happening elsewhere, home and abroad. He could advise on anything to do with a railway.

After the First World War, when the railways were under government control, there were something like 120 independent private companies preparing to take back control of their charges. They had given them up beforehand with most having been in typical condition for Edwardian times – fine, clean and well cared for. That was a golden period for the railways, once the teething problems from the Victorian age had been sufficiently ironed out. In the aftermath there was no way that those companies could take back what they had handed over, for everything showed the effects of having been through the war, some for over six years.

After considering and rejecting a nationalised system, the authority charged with solving the problem came up with the idea of bringing everything under the auspices of just four private companies. They would be regionalised, with constituents losing their former identities. Such a decision limited the number of top-level jobs available. During the war, there had been amalgamations as the owners tried to find a way forward or a way out. Chief Mechanical Engineers (or Superintendents) had remained in charge throughout the period of government control, although they had to adhere to the new state guidelines.

The four obvious regional areas resulting from the new government scheme were London & North Eastern Railway (LNER), Southern Railway (SR), Great Western Railway (GWR) – who were able to retain their former identity – and the largest, the London Midland Scottish (LMS). All of these were later collectively known as the 'Big Four'.

The reign of the Big Four was relatively short, however. Founded in 1923, they came up against the horrors of war within two decades of operation and struggled to survive afterwards. The effects of the Second World War upon the rail industry were much the same as those of the First World War, with the rail system being in no fit state to be handed back to those who had it before. This time, and with the amount of public funding needed to restore the system, the nationalisation solution had to be implemented.

Although short, the years of the Big Four were remarkable times, as the Chief Mechanical Engineers of each company used the platform to express themselves and their company's pre-eminence to the full. They became household names with all the publicity surrounding record speeds, streamlining and stunning designs. The preserved railways of today readily celebrate the designs and liveries of these Big Four companies with their locomotives and rolling stock. Although the country went through difficult times, the railways were one area where the nation could be uplifted.

The inter-war years were a relative glory era for the railways. The streamliner engines appeared and all the pomp that surrounded them and their founders was never far from the headlines. Previously these leading men

would largely have been anonymous, hidden away behind the busy workings of a company, with the general public never needing to know, or much caring, about a railway authority.

In 1939, when war was declared, the Chief Mechanical Engineers of the four railway companies were: Sir Nigel Gresley of the LNER; William Stanier for the LMS; Charles Collett for the GWR; and Oliver Bulleid for the SR, who had taken over from Maunsell in 1937. Gresley was to survive only until 1941, when Edward Thompson took over for the LNER. Thompson, however, lasted only until 1946, when Peppercorn took over. Other changes at that time saw H.G. Ivatt coming in for the LMS after a brief reign by Fairburn. Collett gave way to Hawksworth on the GWR, who was the last Chief Mechanical Engineer of that great company. Robert Riddles had been the main man for the government through the war, introducing the WD types and overseeing other production. He would have another job to do in the near future – that of heading the team responsible for designing the standard classes of engines, which the government would authorise for the new nationalised railway system.

With the coming of nationalisation, and the passing of the private companies, the days of the Chief Mechanical Engineers would also come to an end.

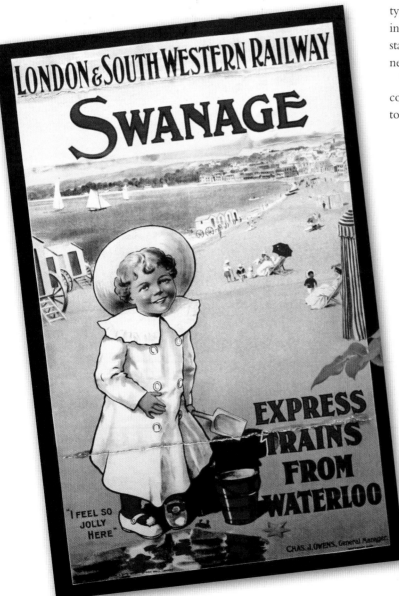

A poster from the heyday of steam showing Swanage in all its glory.

A powerful tank engine of the GWR designed for the valleys of South Wales is at the Dartmouth Steam Railway. No. 5239 2-8-0T *Goliath* runs around at Kingswear to head the train back to Paignton. Note the fully lined-out livery. The engine now has star billing – unlike those past working days. Travellers on the steam railway can transfer here on to the ferry to visit Dartmouth.

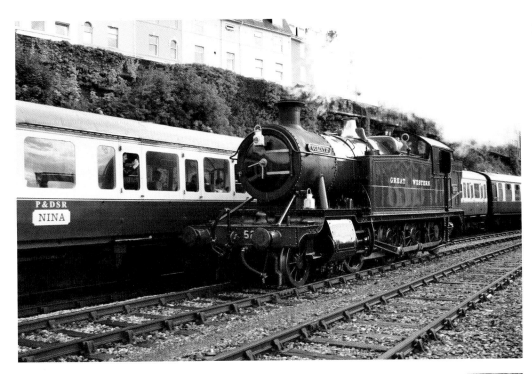

Large GWR tank engine No. 5239 2-8-0T *Goliath* backs on to its train at Kingswear station. The end coach is the Devon Belle observation car. Originally built in 1917 as an ambulance coach, it was then converted in 1921 into a Pullman car. After another rebuild giving it an observation end, the coach was used on the Southern Region's Atlantic Coast Express for a few years. This, though, proved short-lived and it was phased out in the early 1950s.

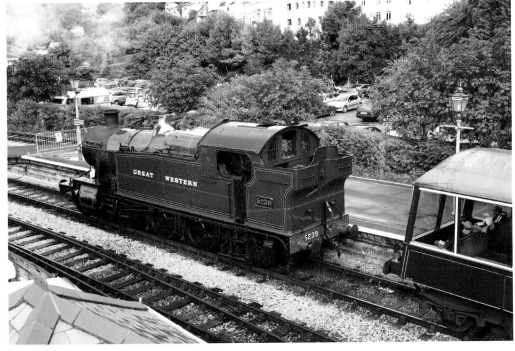

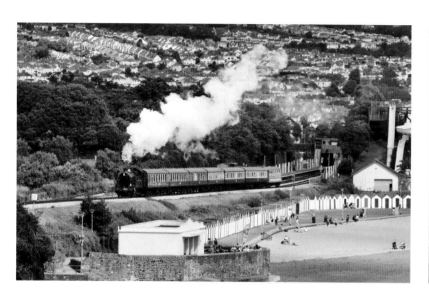

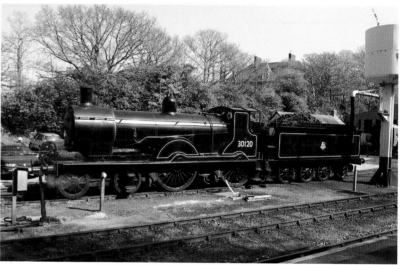

Coming out of Paignton and taking the gradient past Goodrington Sands, the train will shortly be passing inland to re-emerge on the Dart Estuary for the final part of the journey. This is the route the classic GWR Torbay Express took for the final part of its journey from London's Paddington station.

Deep in the West Country, *Greyhound* 4-4-0 L&SWR T9 No. 30120, a past stalwart of West Country passenger runs, now waits between services at the Bodmin General station, which is part of the preserved Bodmin & Wenford Railway. In blackberry black BR livery, we note the early lion and wheel emblem on a high-capacity water-carrying tender. Note the short stovepipe chimney.

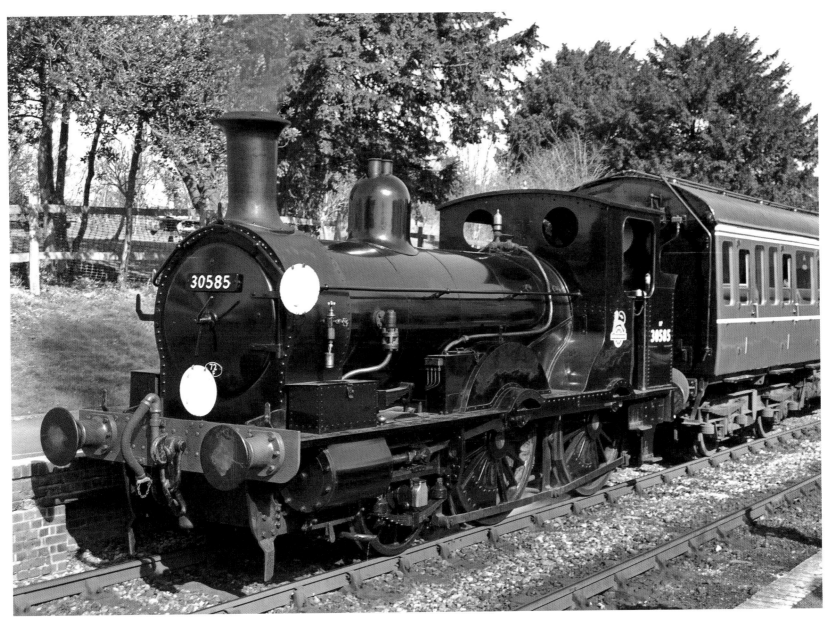

L&SWR Beattie 2-4-0WT (well tank) No. 30585 runs through at Ropley. One of three Beattie well tanks, which were designed for passenger work in the suburbs of London. The three were saved because they transferred to Cornwall, where they worked for seventy years in the china clay industry. Like its sister engine, it came out of Beyer Peacock's works in 1874. The name indicates that the water tank is carried between the frame of the engine, like a well.

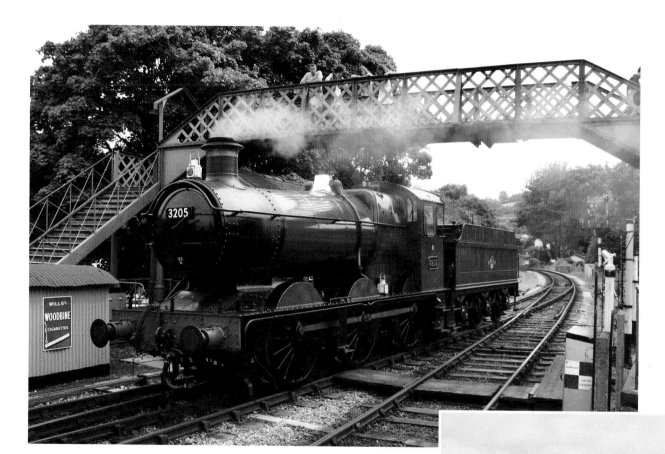

In South Devon, running into Buckfastleigh station is the Collett goods mixed-traffic engine No. 3205, which is the only survivor of a class of 120. Sporting an unlined BR green livery, the loco was very useful for longer branch-line work. The single head-code lamp indicates that of a stopping passenger train.

The magnificent vista of Corfe Castle is in the background, enhanced by the railway passing through at low level. Coming forward we see the Dugald Drummond 0-4-4T M7 loco bringing through a service into Corfe Castle station. This engine was purchased by an American who shipped it to the States only to find that locos without leading wheels were banned there. As such it was returned to England where the powerful little engine has taken up residence on the Swanage Railway.

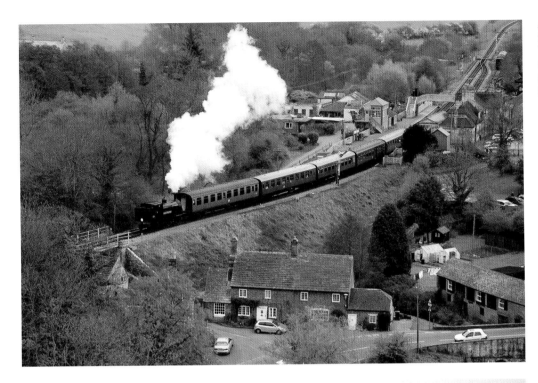

As an opposite view of the previous picture, we can see the train approaching Corfe Castle station from the east. The Dugald Drummond tank engine No. 53 has a train of coaches painted in the classic Southern dark olive-green livery. These colours began to be phased out in the late 1960s and are much missed by the rail enthusiasts.

The remains of Corfe Castle.

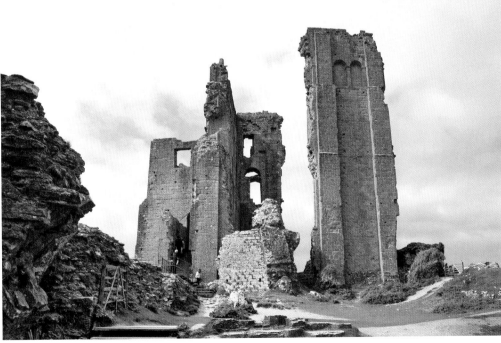

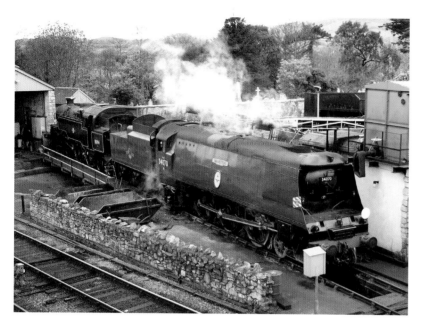

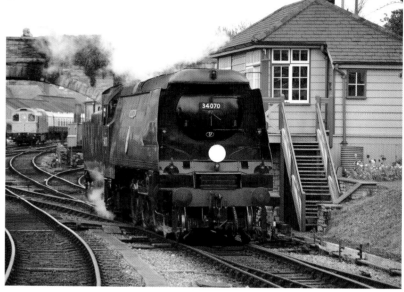

Clockwise from above: The Battle of Britain Class No. 34070 *Manston* is at the Swanage Railway preparation area. Behind it, on the small 40ft turntable, BS large tank engine 2-6-4T No. 80104. The Bulleid Pacifics were the only Pacifics to be built by the Southern Railway. They were introduced in 1941 for the West Country passenger express trains out of London's Waterloo station.

At Corfe Castle is the Bulleid 'spam can' Battle of Britain Class engine No. 34070 *Manston*. The engine is just departing for the final leg of the journey to Swanage. This design was controversial when first mooted. It was wartime and the Ministry of Supply deemed that only goods or mixed-traffic locomotives should be manufactured. Bulleid pushed through this design stating that it was mixed traffic, but in fact they were 4-6-2 (Pacific) express engines.

The unrebuilt Bulleid Pacific No. 34070 *Manston* moves forward to take out its train for another trip to Norden. The engine carries the British Railways livery of lined Brunswick green with the later BR logo. It was built in 1947 at Brighton, which was the last year of operation for the Southern Railway before nationalisation of the railways. This style of casing was largely removed from these classes in the 1950s for them to then be classed as rebuilt.

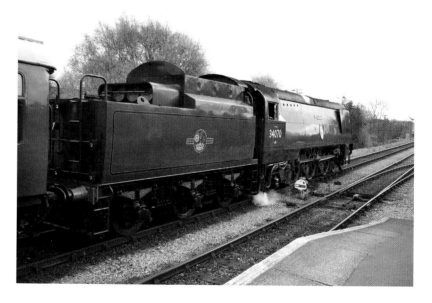

FIVE

SIR NIGEL AND THE A4S

No. 60007 *Sir Nigel Gresley* was always going to be on any list for preservation. As well as its name, the locomotive was destined for preservation when on 23 May 1959 it set a post-war world speed record of 112mph. That was when working a special train from Doncaster to London – the same stretch on which *Mallard* broke the all-time record two decades before. Since setting the post-war record, No. 60007 enjoyed a period of time working in Scotland with a few other A4s before being preserved.

No. 60007 *Sir Nigel Gresley*, No. 60008 *Dwight D. Eisenhower*, No. 60009 *Union of South Africa*, No. 4489 (60010) *Dominion of Canada*, No. 60019 *Bittern* and No. 4468 (60022) *Mallard* are the six engines which have survived for posterity. Four are still in Britain, with Nos 8 and 10 now having homes on the other side of the Atlantic. In the summer of 2014, however, all six came together in a famous gathering where the National Railway Museum were able to offer some great photo shoots both at York and Shildon.

Looking at the steam scene today in one of our heritage centres, the past seems to glisten, so much so that it is easy to forget that these locomotives were the result of more than 100 years of development – from those unsafe early days when the spirit of competition that drove the railways' progress was never far away.

The railways had started something of a travel revolution, as the road system with horse-drawn coaches would have been something to avoid if possible. With the dawn of rail travel, people's lives were changed forever and, as a result, the public were duly excited by the possibilities of travel.

Newspapers looked for stories to feed the public's imagination, with one moment in particular fascinating both press and public alike – the Races to the North.

In the late nineteenth century competition between the railway companies had become intense, so much so that some companies had taken to racing each other along tracks with duplicated routes. The London to Devon run was one example, with the London & South Western Railway (L&SWR) rivalling the GWR to take passengers from London to that very attractive part of south-west England. The L&SWR ran on the southerly route via Basingstoke and Salisbury, whilst the GWR departed from Brunel's marvellous Paddington station through to Exeter and Plymouth via Reading and Bristol.

It was the race to Scotland, however, that really got the public interested. Here, there was the east-coast route of the Great Northern Railway running against the west-coast route of the London & North Western Railway. It all began quite sedately. London's Euston station was the departure point for the west-coast route, going via Crewe, Preston and Carlisle. On the east coast, the train departed from King's Cross and passed up through Peterborough, Doncaster, York and Newcastle. Each route had a departure time from London of 10.00 a.m. for Edinburgh and 8.30 a.m. for Aberdeen. It was the section between Edinburgh and Aberdeen, however, that was of the highest interest. On the last part of that journey from Kinnabar Junction (38 miles short of Aberdeen) there was only a single track, which both trains would have to converge on to. The first train to pass this point could therefore not be beaten.

By the end of the 1890s, it was decided that enough was enough. Man and machine had been stretched to the limit. Sense prevailed with trains then running normally for a couple of decades. It was with the emergence of Gresley's A1(3) Class engine *Flying Scotsman*, however, that interest in the long north–south routes started to re-emerge. It was then that the LNER engine made the first non-stop run between London and Edinburgh in 1928. This was helped by the innovation of a walk-through tender, which allowed crews to be changed at the halfway point without having to stop the train in between.

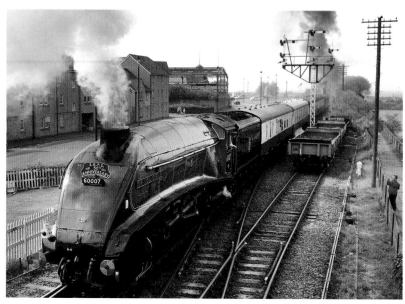

A4 Pacific No. 60007 *Sir Nigel Gresley* often tours the country and here the Gresley Streamliner has arrived at Bo'ness, Scotland. For these workings, the train has a top and tail formation with a little blue engine at the other end. *Sir Nigel* does most of the work and here is performing the banking duty, creating some fine atmosphere on a chilly day.

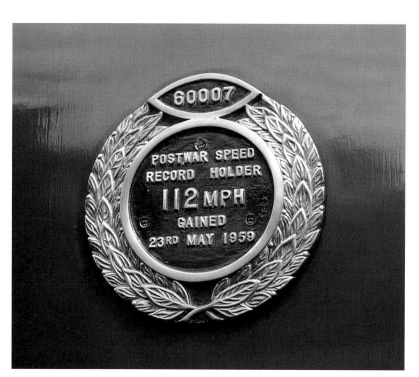

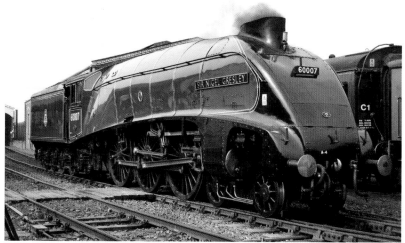

The plaque on the side of No. 60007 reminds us that the engine holds the post-war steam speed record of 112mph (180km/h). The engine has the short-lived ('49–'51) livery of blue, given to all engines with the power classification 8P.

The Gresley Pacific comes off the train at Bo'ness to be watered before resuming duties for a day's work. The design caused a sensation when introduced in 1935. The shape was completely new, and the extraordinary chime whistle at the front of the engine made it an object of wonder.

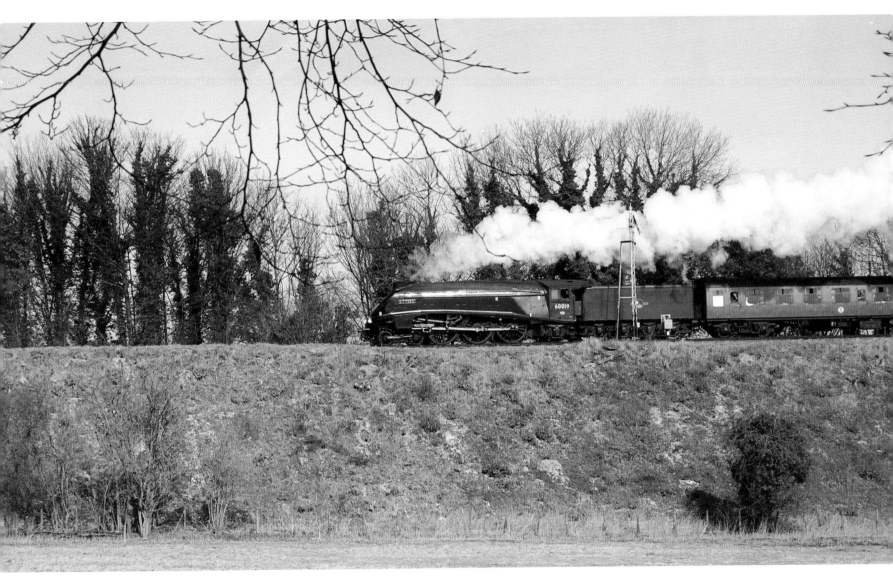

In action at the Mid Hants Railway (Watercress Line) is A4 No. 60019 LNER Pacific *Bittern* high on the embankment on the approach to Alresford. Four of this class have been preserved in this country, with two more being stabled abroad: *Dwight D. Eisenhower* and *Dominion of Canada*.

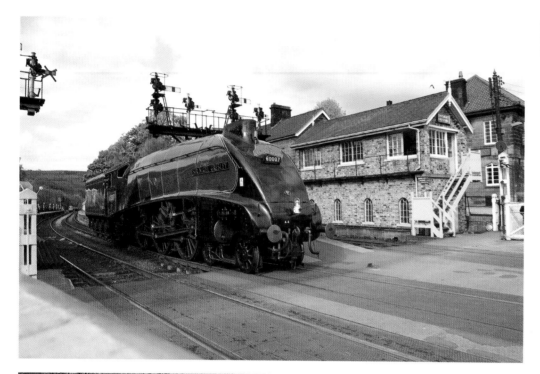

Back on home ground A4 Pacific No. 60007 *Sir Nigel Gresley* crosses the road at Grosmont to head through the Big Tunnel and back to the shed area.

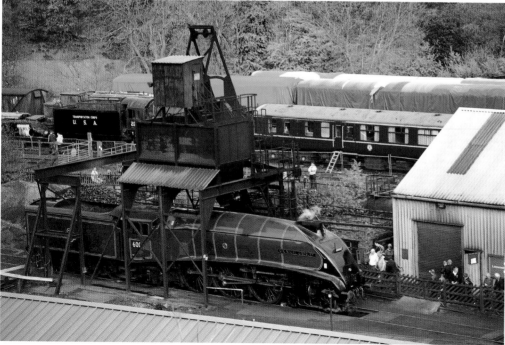

It is the end of the day at Grosmont shed. No. 60007 *Sir Nigel Gresley* is taking coal and having the fire taken down ready for the next day.

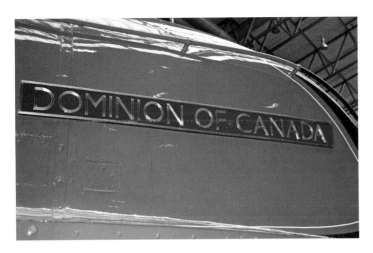

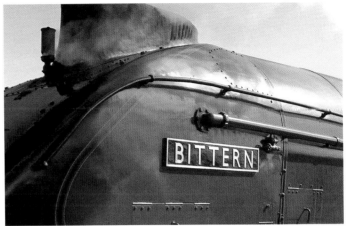

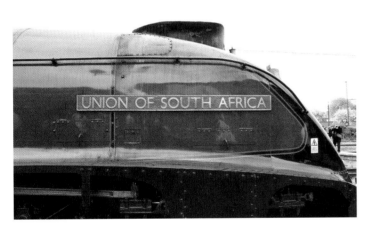

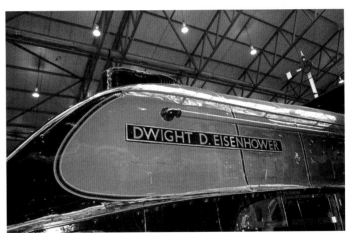

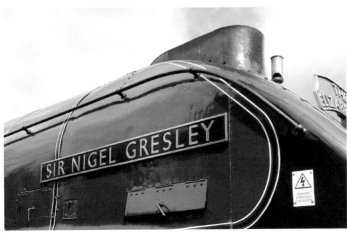

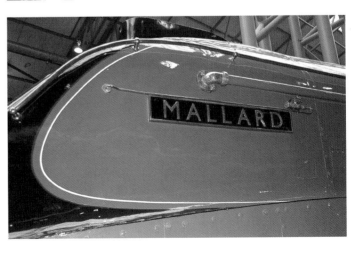

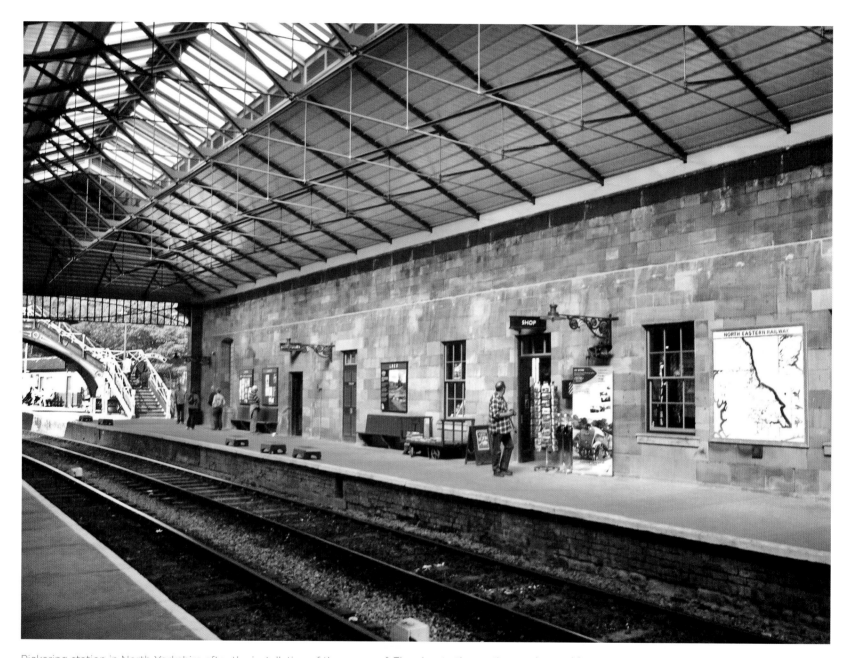

Pickering station in North Yorkshire after the installation of the new roof. The view to the north was always a favourite with the castle behind.

SIX

SOUTHERN INFLUENCE

Southern Expresses

During the Second World War, the Southern Railway played a vital role serving the busy ports of southern England, where goods and serving troops went to and came back from the war. Acting as something of a lifeline, the country's ports were kept strong and supported by the Southern Railway, which supplied them.

Prior to the war, throughout the 1930s, Southampton had grown in importance to become the number one ocean liner port in the world. Images of the *Queen Mary* and *Queen Elizabeth* from the time are still vivid in the mind, with the ocean liner boat trains on the tracks in front of them, of course. These were the little US switchers, which plied their trade during the conflicts, in an area that was one of the top targets for enemy bombers.

The Southern Railway hit a glory period after the conflicts when those Bulleid Pacifics took on the livery of malachite green with sunshine lettering – not to forget a good nameplate, and the name of the train they were carrying. The Merchant Navy Class were named after shipping lines that served that port through those times. (See Chapter 11 about Oliver Bulleid and his eccentric ways.) The final great ship out of Southampton in the days of the steam railways was the *QE2*.

The Southern had pioneered electrification, with the third rail system gradually being expanded until the lines into Weymouth, in the 1960s, completed the system. Pictures of Waterloo station at the time show the steam trains running between lines of electrified carriages – different systems working together in great harmony.

The Southern engines inherited and taken on by Maunsell in 1923 all had the same look about them. Because of the investment in electric traction, the Chief Mechanical Engineer was not given a great deal of scope to produce vast numbers of steam locomotives or a large variety of classes. The steam budget covered just enough to service the needs of the boat trains and the popular runs to coastal resorts.

There is a fine selection of Bulleid Pacifics currently in preservation, some with their air-smoothed casing intact and others where the casing has been removed. The earlier Maunsell types, however, are rare. There is only one King Arthur Class, one Nelson, a few operational Maunsell Moguls and just one Greyhound, the T9 Class 4-4-0 No. 30120. This was built in 1899 and is based at the Bodmin & Wenford Railway. The classic Lord Nelson Class loco 2-6-0 *Lord Nelson* runs at the Mid Hants Railway, together with an S15 of the same wheel arrangement. The S15s were built for mixed traffic while the Nelsons, named after naval commanders, were built with the heavy boat trains in mind.

One of the best classes to come through this period was the V Class, or 'Schools' Class (see p. 103), named after public schools. The 4-4-0 wheel formation had died out and Maunsell revived it, producing one of the best running types on this railway. Many of Maunsell's class types had proved to be shy steamers, which were not improved until Bulleid took them over. He improved the steaming qualities with better super-heating configurations, to which he added that huge chimney. The 'Schools' were designed to fulfil a running problem on the Southern Railway: the severe width restrictions on

the London to Hastings line. Narrow carriages were also produced to ride behind the V locomotives. So good and useful were these engines that they proved perfect for all the short–medium runs on the railway.

Three of these 'Schools' engines have survived and all are likely to run at various times in the future – when their home railways can raise the funds to get them a ten-year boiler 'ticket'. That is the timescale all running locomotives have before the boilers and other parts have to be exposed, serviced and tested. No. 30925 *Cheltenham* has been running recently at various locations around the country, its three-cylinder beat, in particular, being admired by enthusiasts.

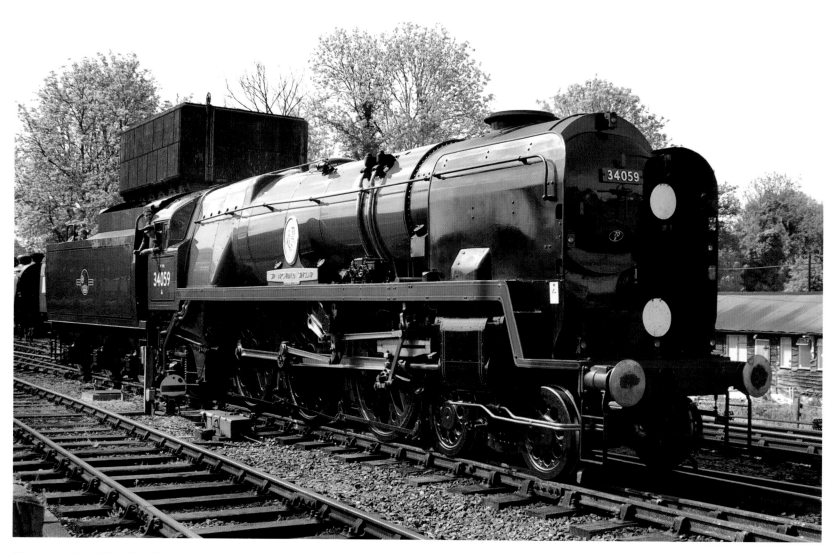

This is how the Bulleid Pacifics looked with their air-smoothed casing removed. At the Bluebell Railway, rebuilt Battle of Britain Class No. 34059 *Sir Archibald Sinclair* runs into the station at Sheffield Park. The nameplate shows the name *Sir Archibald Sinclair*, who was wartime Secretary of State for Air.

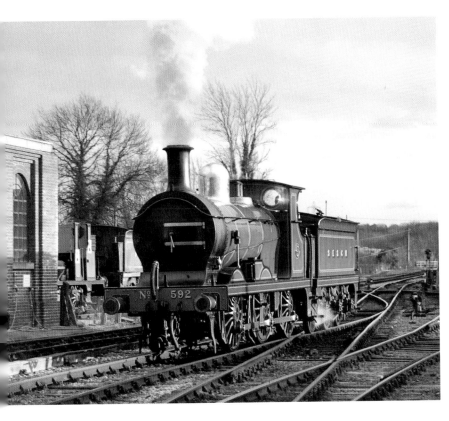

Top left: Ex-SECR C Class No. 592 (BR 31592) is running out of service at Sheffield Park. The evening sunlight catches the sumptuous Edwardian livery.

Bottom left: The C Class No. 592 waits with its train at Horsted Keynes. The carriages include the Chesham set, which were restored by the Carriage Works at the Bluebell Railway.

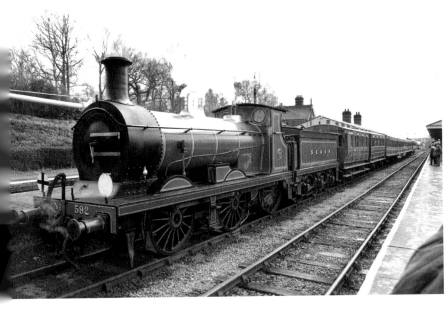

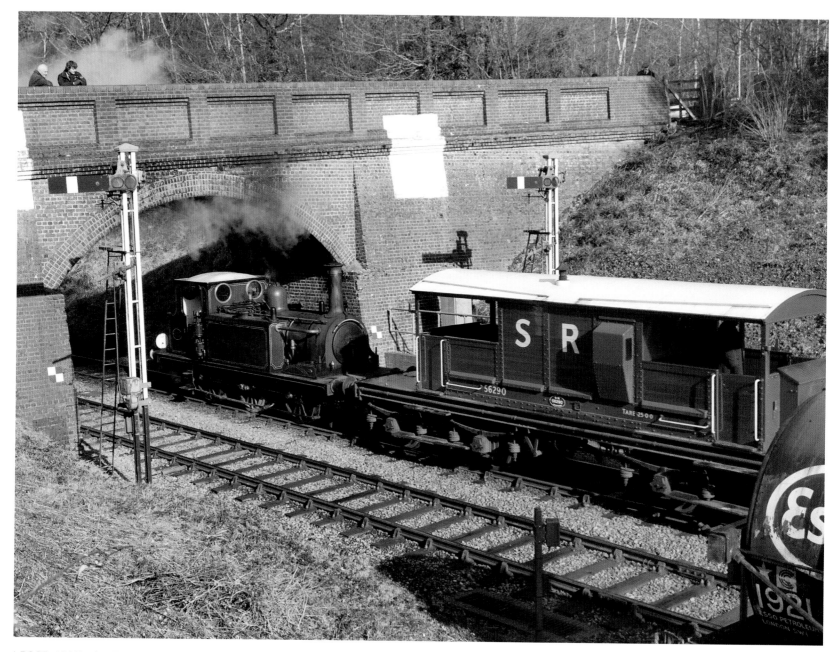

LBSCR A1X Terrier 0-6-0T No. 672 *Fenchurch* works a goods routine outside Horsted Keynes. Note the bogie express goods brake-van with fitted brakes.

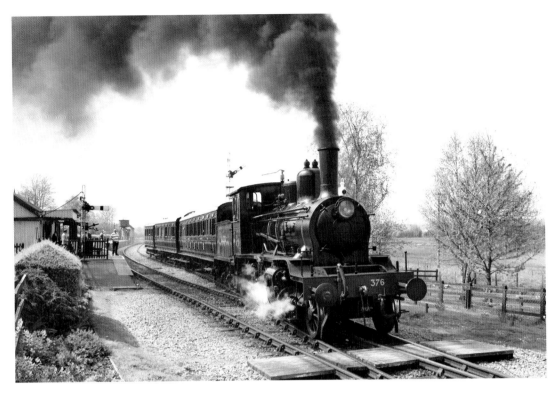

The Norwegian steams out of Northiam, bringing the train onwards towards Tenterden. Built in Sweden in 1919, and having worked in various parts of Norway, No. 376 was acquired by the Kent & East Sussex Railway in 1971 and now performs regularly with the vintage sets of carriages.

No. 376 *The Norwegian* climbs the Tenterden bank with its train of Edwardian coaches.

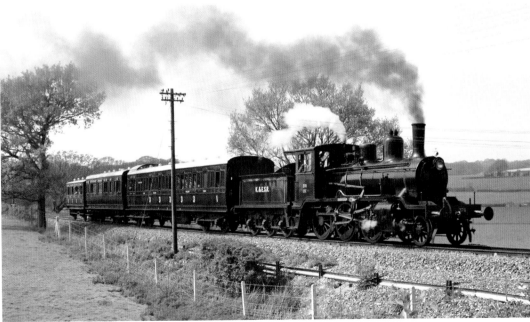

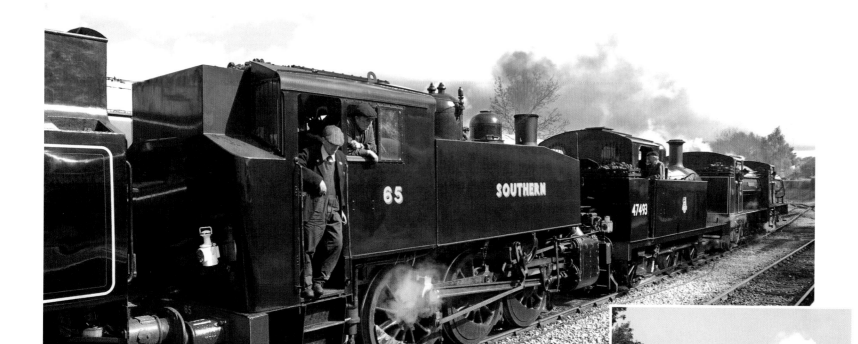

American switcher USA Class No. 65 (a veteran of Southampton Docks in wartime) makes up the numbers for a morning parade at Tenterden station in Kent.

A magnificent view of Horsted Keynes station in the morning sunshine as No. 34059 gets the road to take out the first service of the day, the 11.00 from Sheffield Park. The spare steam, at 250P.S.I. pressure, gets sent high into the air.

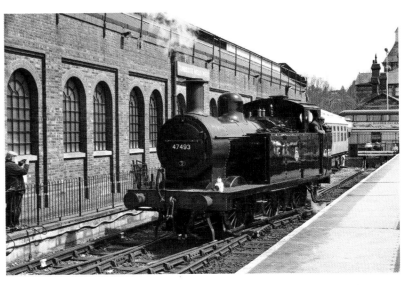

The Spa Valley Railway at Tunbridge Wells, Kent, has extended in recent years to run from Eridge to Tunbridge Wells West. The home-based 'Jinty' is about to take up a position at the front of the next service out. The engine is LMS 3F 0-6-0T, built at the Vulcan Foundry Ltd in 1928.

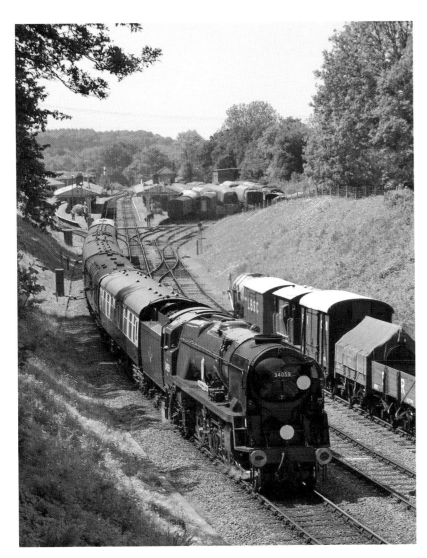

Battle of Britain No. 34059 *Sir Archibald Sinclair* runs through the cutting outside Horsted Keynes station, catching some shafts of sunshine along the way.

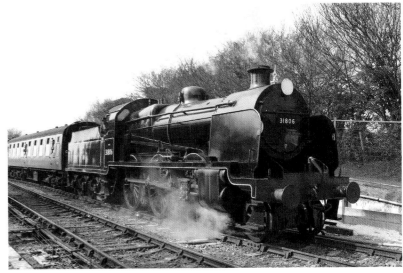

A typical Southern Railway steam locomotive is No. 31806 U Class 2-6-0 from 1928. One of Maunsell's Moguls but of a design introduced before the 'grouping'.

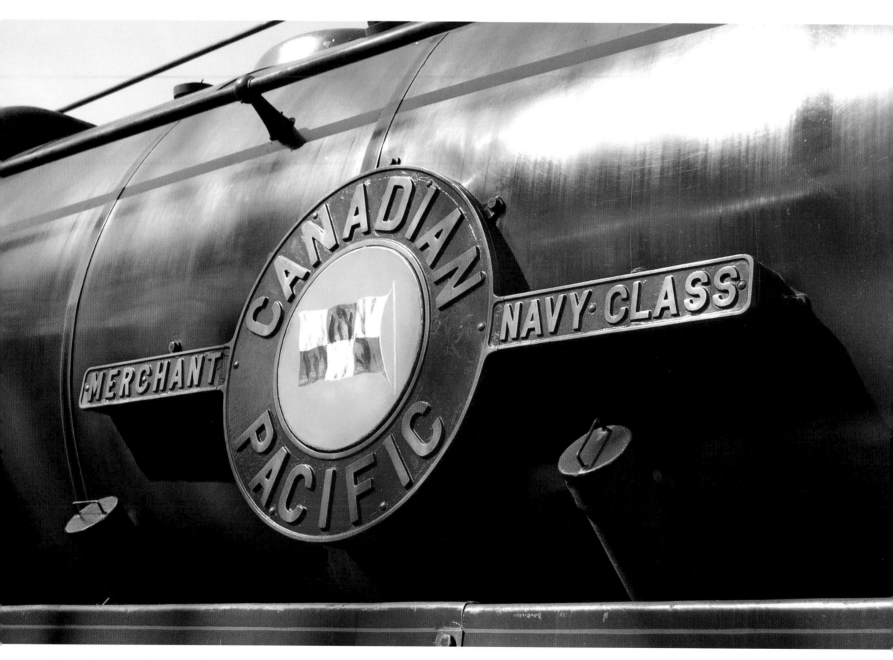

Nameplate from a Merchant Navy locomotive. The names of the Merchant Navy Class were given to commemorate the merchant shipping lines that were involved in the Battle of the Atlantic and those who used the Southampton Docks. All were later rebuilt.

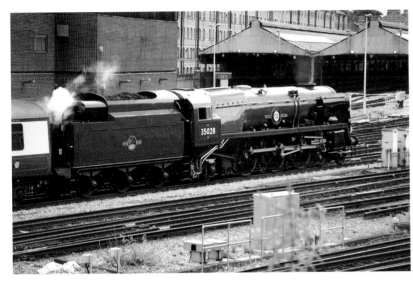

A Merchant Navy in action on the main line. A Bulleid rebuild, Merchant Navy Class *Clan Line* takes the Orient Express away from Victoria station and progresses along one of the busiest stretches of line in the country.

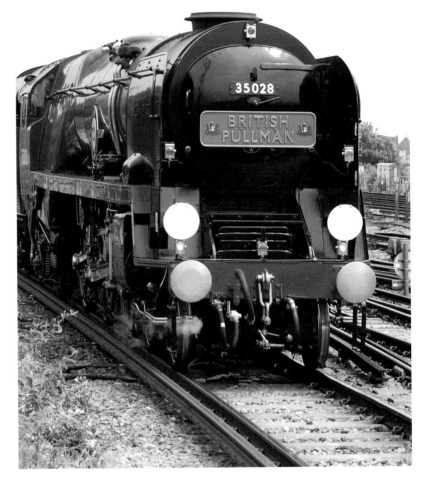

The train has arrived at Clapham Junction to run through the country's busiest station before making a tour for a lunchtime special. *Clan Line* had the good fortune to be taken into private ownership just about at the time steam finished, in 1968, and did not therefore require the major reconstruction most of the locos have needed.

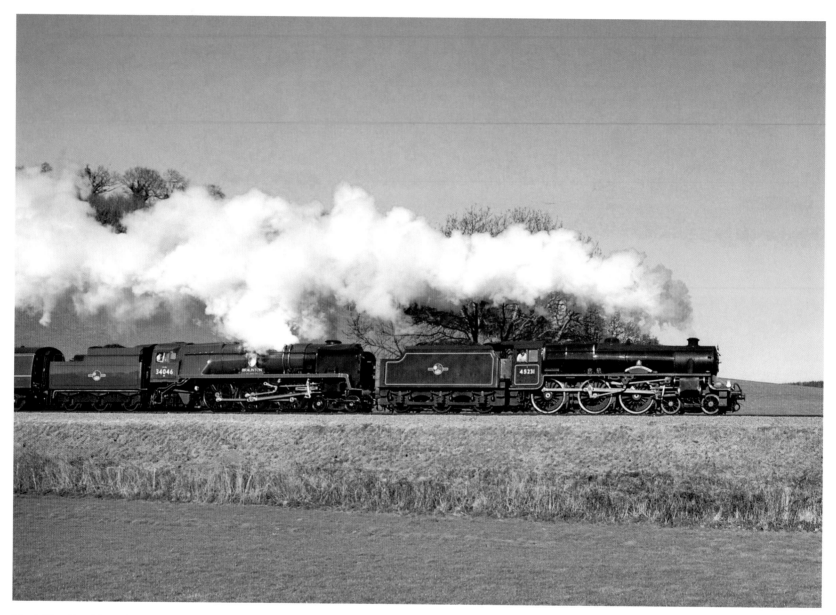

Black Five No. 45231 *The Sherwood Forester* pilots the rebuilt West Country Class No. 34046 *Braunton* as the train proceeds along the West Somerset Railway. The double-header turns into a southerly direction having left Williton to head towards Bishops Lydeard.

WARTIME AT THE GREAT CENTRAL AND SEVERN VALLEY RAILWAYS

War Operation

In the decade before the Second World War, the railways were optimistic in their approach. This was the decade of streamlining and speed running. It was, however, all to be a false dawn, brought to a screeching halt by the declaration of war in September 1939. The future of the big celebrity locomotives of the 1930s was going to be in the more mundane work suited to a time of conflict and repression. Although it had been over twenty years since the First World War, much of the knowledge of how to run rail systems in conflict was within living memory, with the best of this coming straight into the planning of operations for the new war. One important procedure, in particular, was the pre-planned evacuation of children from cities and vulnerable areas, which was put into practice very early in the war and which required the use of the railways to access these safer rural areas.

Before, there had been a Ministry of Munitions who took over the running of the railways together with identifying the types of locomotives that should be produced. They selected the Robinson 2-8-0 engine (one of which still runs at the Great Central Railway) as the ideal example for the purpose. There was also a central control centre, which had previously proven effective. From this experience, a Ministry of Supply was set up for the duration, whose duty was the control of war movement operations. The new ministry deemed that the LMS 8F 2-8-0 was the most suitable locomotive for war use and priority should be given to producing large numbers of these for home and overseas use. Many locomotives that had been earmarked for scrap also got a new lease of life.

Rail operations in wartime would eventually be blighted by the threat of air raids, but in the first year or so of the war there was little activity on this front. From September 1940, though, all this was to change when the Blitz began.

The Southern Railway was the railway most in the firing line, as it operated the closest to mainland Europe and, therefore, had the job of transporting troops and equipment to south coast ports in the build-up to D-Day.

Movement of people by road was almost impossible in wartime, especially at night when total blackout was enforced. Petrol rationing was in place for the general public and, in case of invasion, road signs had been removed. As a result, the whole pressure of public transport was placed on the railways. Very soon the public were made aware that they had the least priority where travel was concerned. Signs saying 'Is your journey really necessary' appeared at every station and delays became the normal practice.

Goods traffic became an immense problem and, as before, a central control was set up to oversee all movements and keep track of the whereabouts of all goods wagons. All privately owned goods wagons were requisitioned for the war effort. As well as the running of general traffic, coal and minerals, iron ore, food and war machines had to be moved. There was a time in 1942 when dozens of new airfields were being constructed in the east of England. Hard core was transported from the bombed-out buildings in London to become the substructure for the runways and hangars – another severe exercise in the movement of a difficult material. Freight had to be moved from coastal shipping on to the railways, which also added pressure. And, as well as the evacuation of children from urban areas, troops had to be evacuated from Dunkirk, which demanded priority of workings. Again, this largely affected the Southern Railway.

Long-distance trains often had to have additional carriages attached, sometimes taking the total to over twenty. This would put severe pressure on man and machine, with not only the start and finish stations having difficulty of operation. At stops, the train would have to be pulled up once or twice to allow rear passengers to exit. Demands for more men and locomotive power grew with shifts being extended to a degree that would be unrecognisable today. Ladies came in and filled many of the jobs where the training time was shorter.

One consolation for rail operations was that the rail network was at its height – cuts in lines were yet to begin. The demands of war transportation were very different, however, from those of peacetime. Most of the previous systems radiated from London, but more cross-country and north–south movements were required, which would lead to bottlenecks. Also, it became apparent that many of the secondary routes were more lightly laid than the main lines. At critical bottlenecks, such as routes going past main rail centres and some of those which would have to feed the build-up to D-Day, the lines had to be doubled up from two to four tracks. Some of the London stations had the glass removed from their roofs as a precaution in case of bombing. Cannon Street station did this and had all its glass stored in a warehouse. Unfortunately, that warehouse was hit by a bomb and all the glass was destroyed. After the war, the glass never got replaced and the carcass of the iron roof remained unglazed. By the late 1950s this structure had rotted sufficiently that it all had to be removed. Cannon Street station remained roofless for about two decades before an office building was built in the space above it.

For obvious reasons, matt black became the standard colour for locomotives during the war, with even the brass and copper work of the GWR engines being painted black.

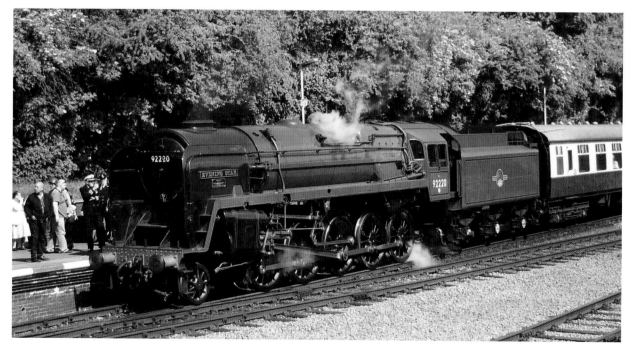

At Leicester North on the Great Central Railway the Riddles BR Standard 9F No. 92214 Class 2-10-0 arrives at the terminus. For a very short time this engine is disguised as No. 92220, taking the identity of the last BR engine ever built, *Evening Star*. Robert Riddles designed the wartime 2-10-0 WD engines and perpetuated these when he led a team to produce the British Standard range of locomotives in the early 1950s. This is one of those.

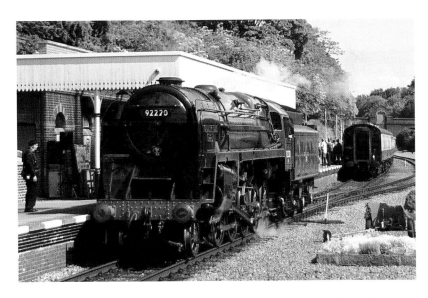

The counterfeit *Evening Star* runs off its train at Leicester North on its first run of the day at the annual war recreation event. The real No. 92220 is firmly entrenched within the National Railway Museum some 90 miles further north at York, No. 92220 being the last ever steam engine built by British Railways. For this, there were embellishments added such as extra lining and a copper band around the chimney.

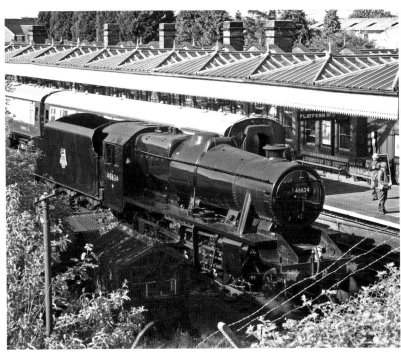

The 8F 2-8-0 No. 48624 waits in the bay platform of Loughborough Central station before taking its place at the head of the evening dinner train. The station is showing the benefit of having a recent complete roof overhaul.

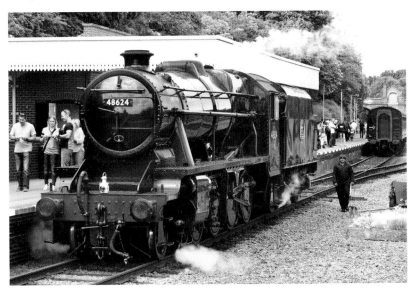

LMS 8F 2-8-0 No. 48624, in black livery with the early BR lion and wheel emblem on the tender, runs around in the morning sunshine at Leicester North. The class was selected by the Ministry to be the engine for war and this example was built at Southern Railway's Ashford Works for that purpose in 1943.

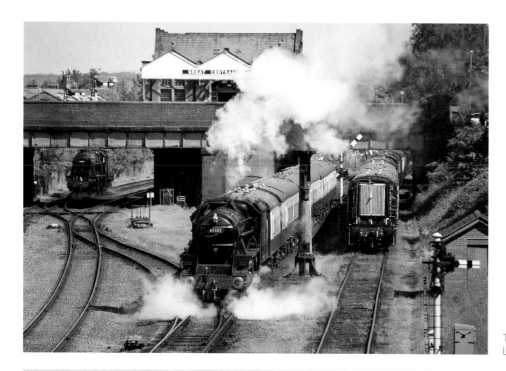

The Stanier whistle blows and the southbound service leaves Loughborough Central station.

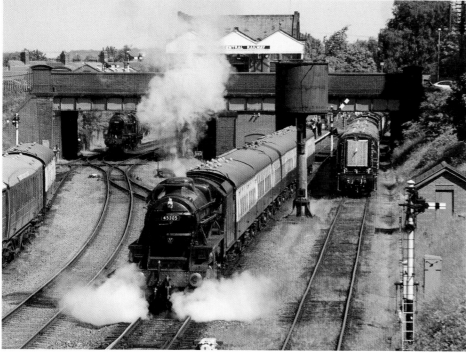

LMS Black Five 4-6-0 No. 45305 truly represents an engine suitable for use in times of war. Together with the 8F 2-8-0 No. 48624 (which can be seen at the back of the picture), the Great Central Railway has two great representatives for the Railway at War weekend. The train gathers speed for the run down the racing stretch of double track.

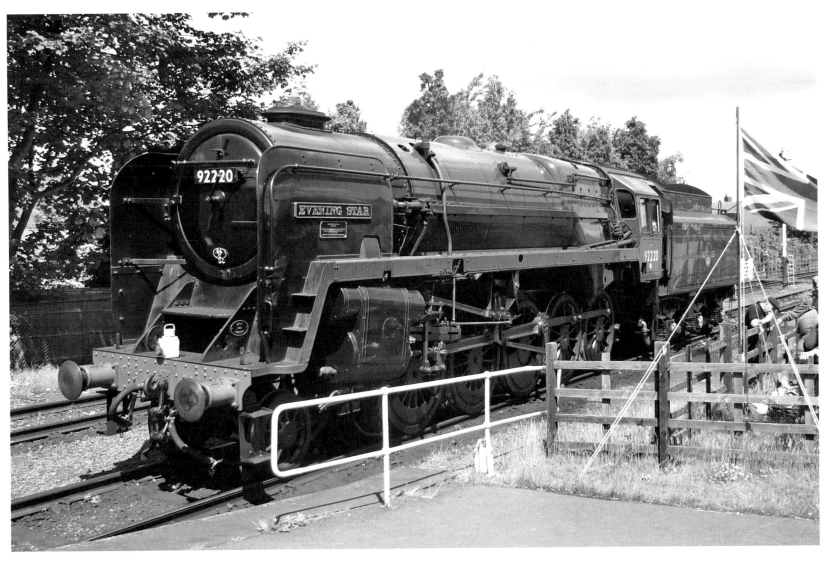

Riddles BR Standard 9F *Evening Star* No. 92220 Class 2-10-0 (not the real one, of course) is now at Loughborough Central. The annual celebration of the 1940s is in full swing but perhaps this class of engine was not the best of choice, as they were not actually in production until the 1950s.

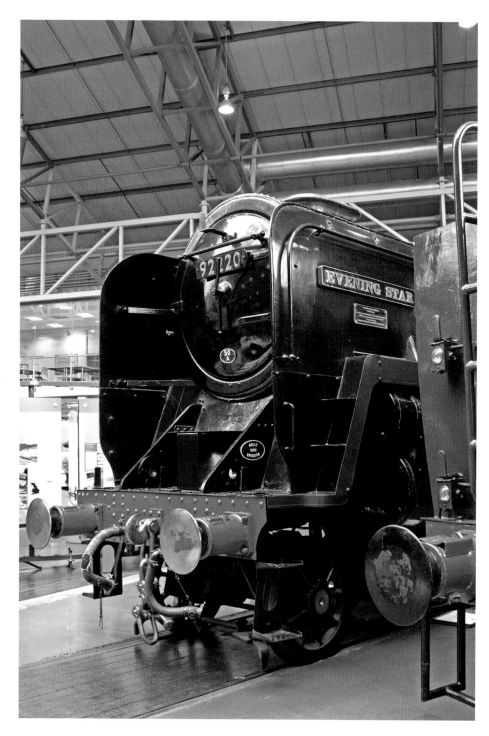

The genuine *Evening Star* is sitting quietly at the National Railway Museum, perhaps a little envious of its sister engine running around in its name. Note the real copper band to the chimney – no paint job here.

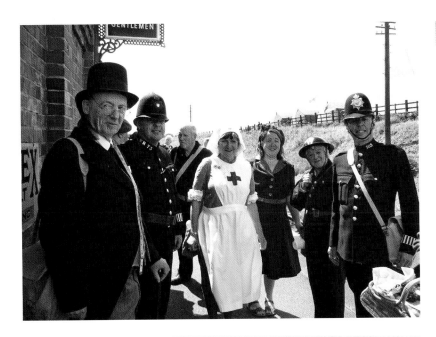

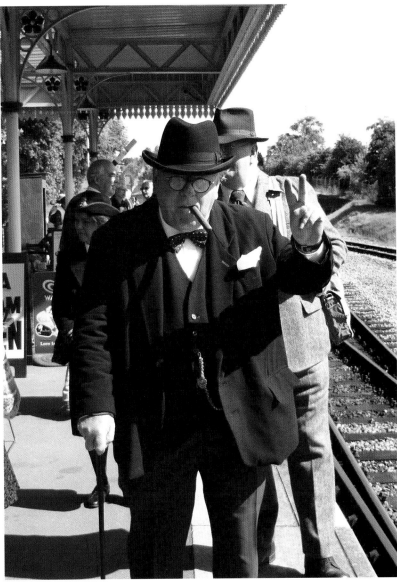

Clockwise from left: Mr Mannering is here with his wife making a rare appearance; With so much action going on at the railway, all services have to be at the ready – including the undertaker; Hello Mr Churchill – Sir.

Royalty and high dignitaries are watching the forces show at Quorn.

Here's one young lad who doesn't appear too enamored with the thought of evacuation.

This German soldier looks so mean he's really going to scare people away.

The Germans have such a strong hold at Rothey that Field Marshal Rommel makes an appearance.

A selection of cars has made it, despite the severe petrol rationing.

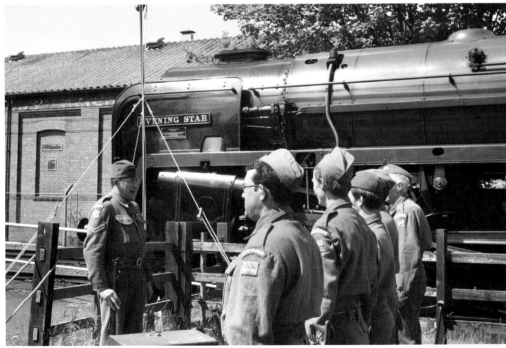

Home Guard patrols are taking place at Loughborough.

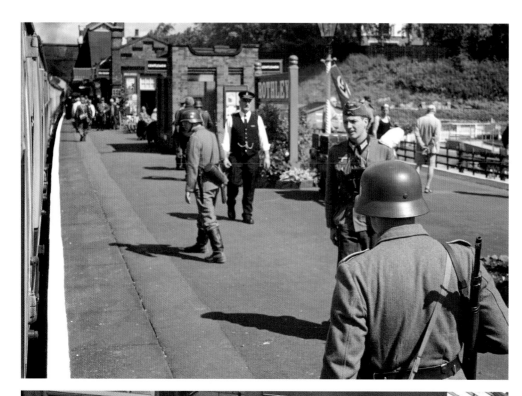

Rothley station is held by the enemy. Any undesirables on the train may be dealt with.

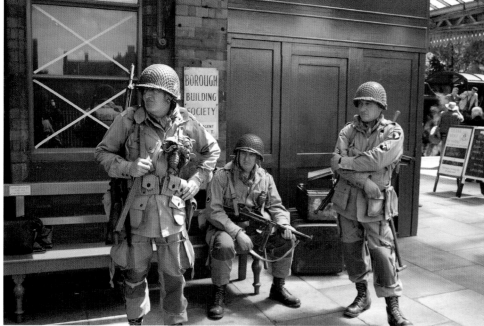

The American GIs are hoping to get to London. But today no services are running south of Leicester.

The LMS 8F No. 48624 had previously been presented in a very appealing, although less than authentic, maroon. Here's a glimpse of how it was for all those people who rather took to it in that fetching turnout.

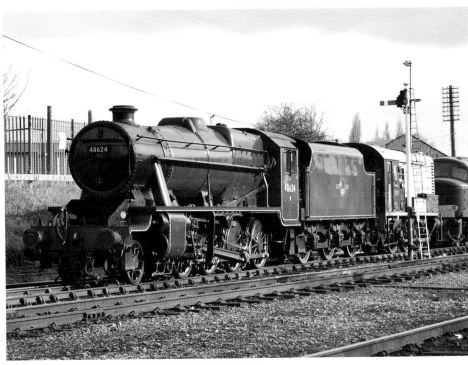

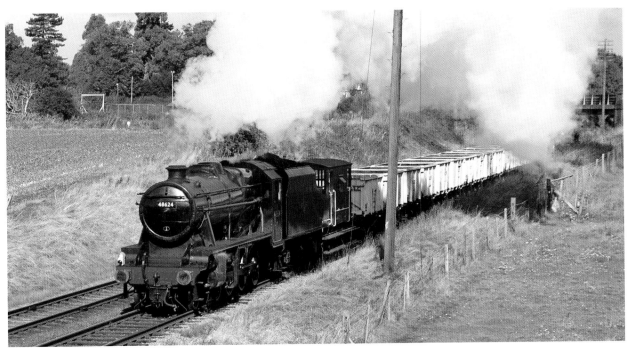

The maroon-liveried 8F hits the main-line running track out of Loughborough, hauling the rake of mineral wagons.

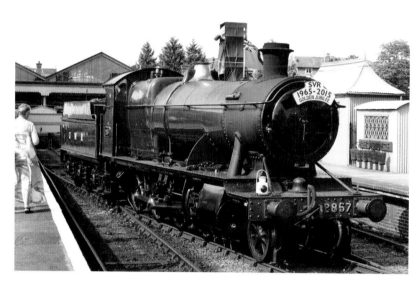

Class 2800 No. 2857 (1918) 2-10-0 switches tracks at Kidderminster to run around the train. One of the GWR's standard freight locomotives designed to pull the heaviest loads. The very typical Swindon design is full of parts interchangeable with other classes. This example was rescued by the 2857 Society from Barry scrapyard in 1975; this is typical of a group who were determined to keep steam alive.

Side view of GWR tank engine 1400 Class 0-4-2T (1935) No. 1450 at the end of the day at Bridgnorth – a class designed with push-pull workings in mind. With a basic power classification of 1P, they were withdrawn to make way for diesel multiple units.

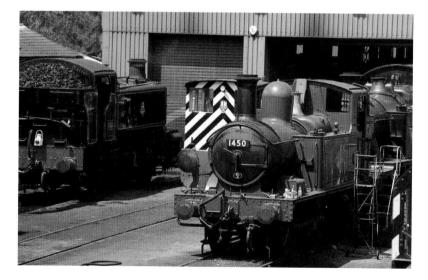

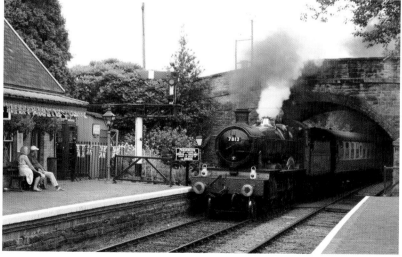

GWR tank engine No. 1450 0-4-2T is in the foreground at Bridgnorth shed, whilst Hawksworth Pannier No. 1501 has returned from its travels around the country to take up residence again at its own base. Here the loco acts as reserve engine in steam for the day.

GWR No. 7812 *Erlestoke Manor* (1939) comes into the much-acclaimed Arley station with a service bound for Bridgnorth. Many film and television productions head here, and with the magnificent gardens, it isn't hard to see why.

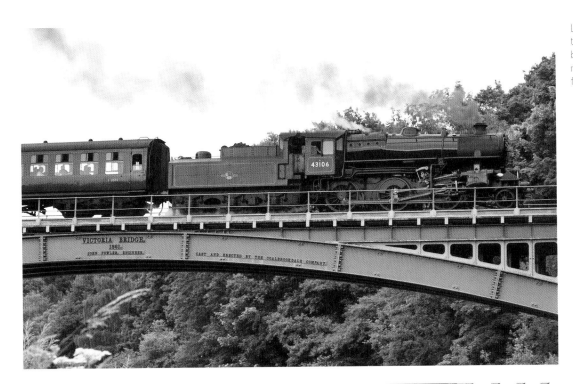

LMS *Mogul* 2-6-0 (built 1951 at Darlington) crosses the Victoria Bridge near Arley. A post-war design by H.G. Ivatt, which continued to be used after nationalisation. Riddles then used these as a basis for the British Standard Class 4 series.

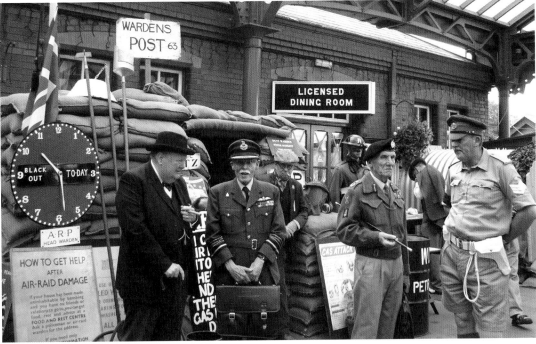

Churchill, Montgomery and the air vice marshal stand in the safety of Kidderminster station.

WH Smith bookstall with wartime products.

Evacuees come off the train at Kidderminster after a long journey, hoping to find good homes for the duration.

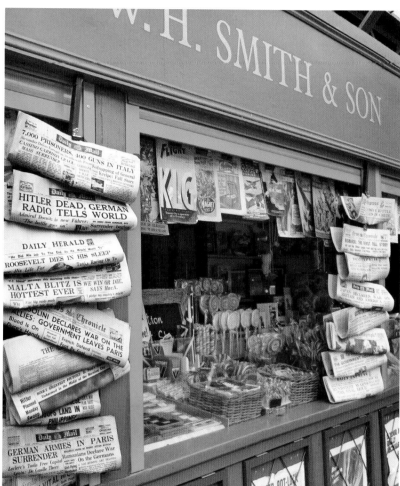

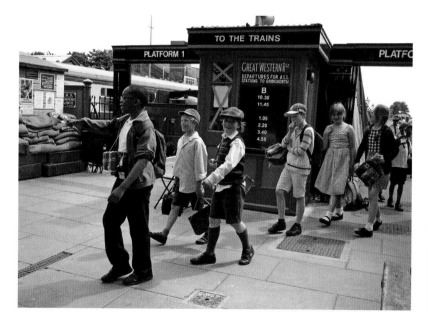

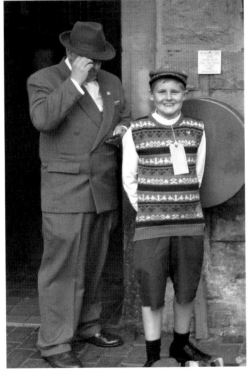

Clockwise from left: Shoeshine boy on Bridgnorth station; Severe wartime problems on the forecourt outside Kidderminster station; Kitchen utensils or perhaps musical instruments.

Mr Churchill waits at Kidderminster.

Churchill poster.

EIGHT

GWR, MIDLANDS TO WALES

Dai Woodham

The story surrounding Dai Woodham and his Barry Island scrapyard is now legend within railway history. The steam engines might well have operated for a century and a half in Britain, but they will live for much longer as part of the preservation movement. The scale of that survival is due largely to the fact that the Barry scrapyard found it easier for themselves to cut up wagons and small parts before finally turning their attention to the awesome task of cutting up those steam locomotives. Their company had changed from focusing on general salvage to railway scrap as far back as 1959 following British Railways' announcement of their modernisation plan in 1955. British Railways were getting out of steam as fast as they could, which meant some fine business opportunities in the scrap-metal business.

The Woodham brothers took the opportunity and made themselves available to take as many locomotives and parts as their site would hold. They also took leases on adjoining redundant railway marshalling yards, which soon led to large numbers of redundant engines arriving from Swindon. The locality of the scrapyard largely dictated the types of engine they would get. In the final instant there was only one locomotive from the Eastern Region – B1 No. 61264, 4-6-0, built 1947. By chance, a good many Bulleid Pacifics landed there, which led to the large numbers of these classes being readily available. Also, of course, there were huge numbers of ex-Western Region types as well as British Standard types. The locomotives started to come in together with other rolling stock and scrap rail.

The Woodham brothers found that they could fulfil the needs of the steel industry by cutting up rolling stock, scrap rails and other items, largely sparing the locomotives. Some locos did get scrapped but in doing this they set their work patterns for the future. The engines kept coming, and in all these totalled 297. Out of this number, 213 were eventually saved and taken away by preservationists to be the mainstay stock for the burgeoning heritage railway industry.

Young men who had involved themselves in the setting up of the suitable sections of line, which were soon to become heritage lines, quickly found out about Barry Island. They soon arrived there to choose an engine and put a deposit on it. The problem of paying the outstanding amounts would be thought about later. Much fundraising would be necessary, with activity at their sites and adverts in papers to get people interested.

The first engine to depart with the preservationists from Barry was the former LMS 4F 0-6-0 No. 43924 which headed off for Keighley and the Worth Valley Railway. That railway went from strength to strength after taking over a 5-mile branch line. The last engine to leave Barry was a GWR Prairie tank engine No. 5553 in 1990, which had been there for an incredible twenty-eight years.

Dai Woodham had soon realised the good business of selling a locomotive whole as against having the trouble of cutting it up and getting the same money for it. He died in 1994, but not before he realised the part he had played in setting up a piece of Britain's industrial heritage. We owe thanks to all those people who went down there and took one away. That was the start, but there was still the task of rebuilding those hulks – which often took a couple of decades.

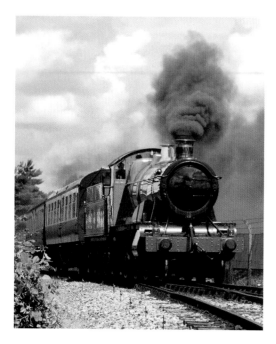

Left: 43xx Class 2-6-0 No. 5322, built in 1917. Given the ROD (Railway Operating Division) identity, it was shipped to France for war use from new. Here at Didcot it gives a spirited run along the demonstration line.

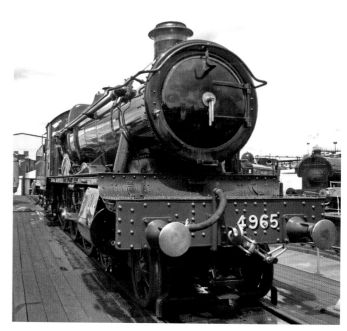

Right: GWR Hall Class 4-6-0 No. 4965 *Rood Ashton Hall*. Appearing at the Tyseley Locomotive Works, Birmingham. The engine was built for the GWR in 1929 at Swindon. A hugely successful class of mid-range engine, the last Halls were being built at the same time that the early ones were being scrapped. After the war, a Modified Hall range was produced to extend their life with technical and running improvements.

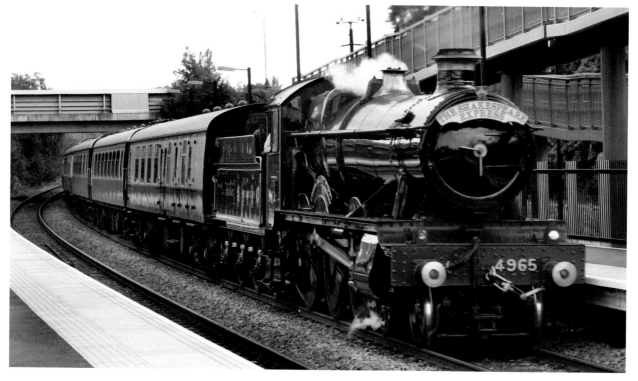

The Tyseley locomotives get a regular run out on the main line. No. 4965 *Rood Ashton Hall* has a regular routine taking a vintage train service to Stratford-upon-Avon and back. We catch the train gaining speed coming through Stratford Parkway on the home run.

GWR No. 5043 *Earl of Mount Edgcumbe* is on the turntable at Tyseley for the open day. Also in the picture is LMS No. 5593 Jubilee Class *Leander* looking brilliant in crimson-lake livery. Castle Class No. 5043 was outshopped from Swindon in 1936 as a foil to the Kings, having just about as much speed with the same load, but slightly less power.

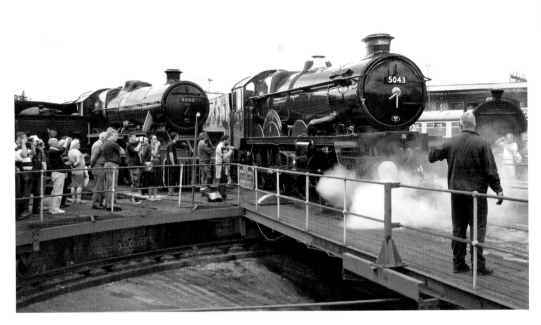

Now right on the turntable at Tyseley, GWR No. 5043 *Earl of Mount Edgcumbe* is resplendent in the classic post-war express train livery of lined Brunswick green and showing the lion and wheel logo on the tender.

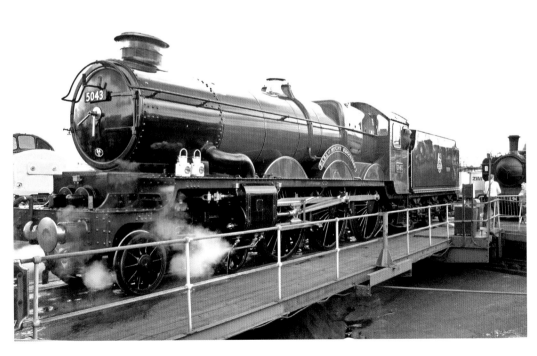

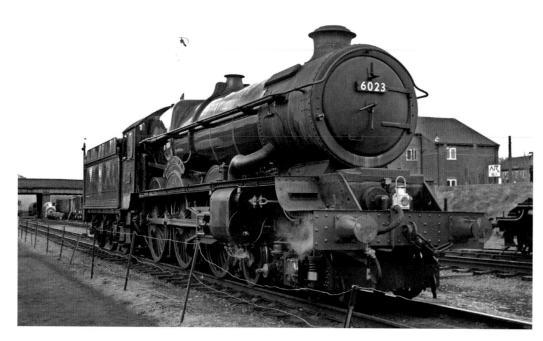

The King in all its splendour. The most powerful engine of the GWR is on a visit to the Great Central Railway. The four-cylinder class was limited to four routes owing to their power. Here, No. 6023 *King Edward II* looks supreme in the short-lived livery of BR blue (1949–51). This engine was a resident of Dai Woodham's Barry Island scrapyard, where it was badly damaged by having the driving wheels cut away. Preservationists weren't deterred, spending two decades bringing the engine back to what we see today.

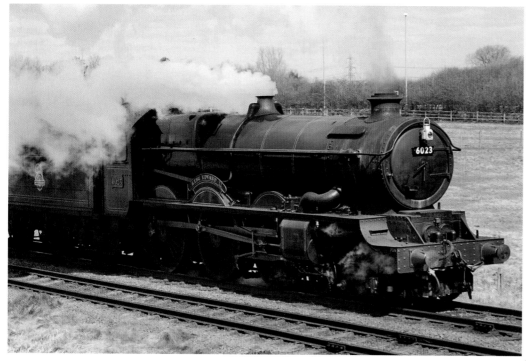

No. 6023 *King Edward II* runs out of Loughborough on a southbound journey.

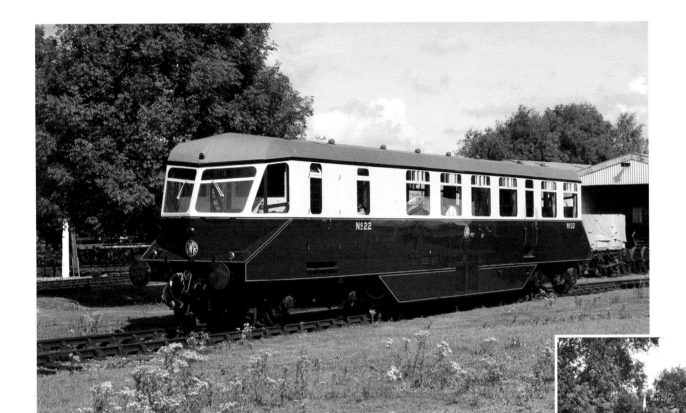

A diesel railcar that every Great Western follower will love. Unlike the DMUs (Diesel Multiple Units), which followed the steam days, these railcars had style and charm.

The diesel railcar No. 22 runs along the branch line at the Didcot Railway Centre. This recreates a classic sleepy branch line scene from the GWR. The railcars first appeared on the scene in the 1930s and lasted until the more modern DMUs replaced them. There was even one fitted out to be a parcel carrier and was often seen coming and going from the Paddington parcels platform.

Another example of a late Pannier tank introduction, produced for the GWR by Hawksworth. The powerful 0-6-0PT No. 9466 Class 9400 GWR (WR) Pannier tank prepares to go into service at Loughborough. With all the copper and brass embellishments, Hawksworth was keeping up all the standards of the Great Western tradition.

In action at the North Norfolk Railway is a type of Western Region Pannier tank with outside motion. These predominantly lugged the empty sets of carriages in and out of London's Paddington station right through the 1950s. Introduced by Hawksworth, 1500 Class No. 1501 0-6-0PT came out of the Swindon Works in 1949.

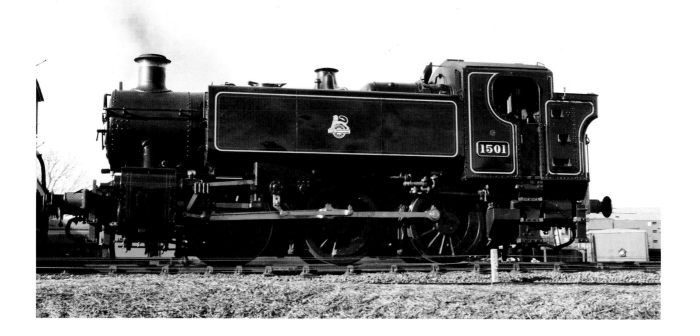

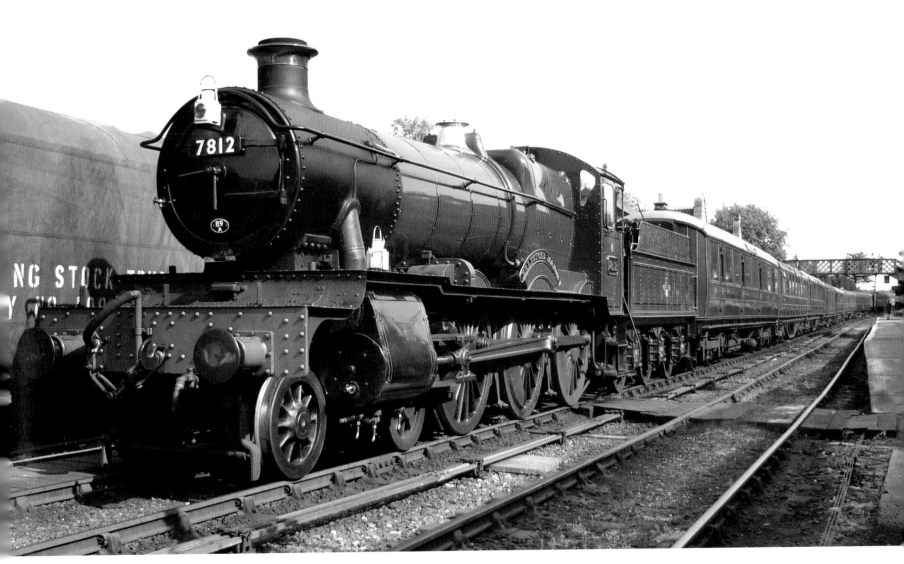

No. 7812 *Erlestoke Manor* finishes its turn of duty by arriving at Bridgnorth station with the Gresley teak-bodied set.

On a rare placid and serene evening, No. 7812 *Erlestoke Manor* stands in front of sister engine No. 7802 *Bradley Manor* at the Severn Valley shed area. Nine of this class have survived into preservation. From an original manufactured number totaling thirty, built before and after the Second World War, the proportion that have survived totals nearly a third – the best figures for a class of front-line engines.

Edward Thompson, the Chief Mechanical Engineer who took over from Gresley on the LNER, introduced the B1 Class. No. 1306 (BR 61306) *Mayflower* is on a visit to the Battlefield Line near Leicester, where it presents a fine picture. Built in 1948, the loco has the LNER lined apple-green livery, which was used for a while after nationalisation. The engine brings a service into Shackerstone station.

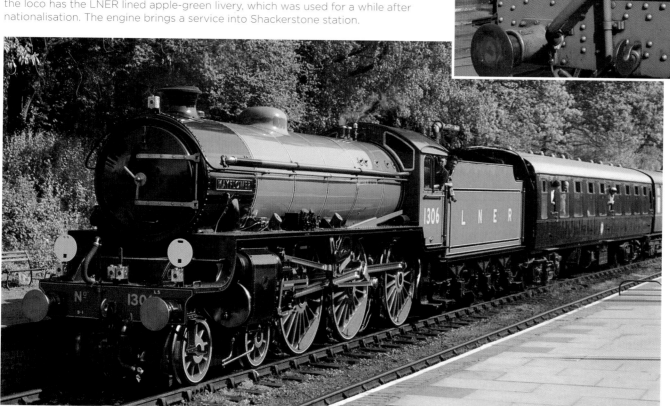

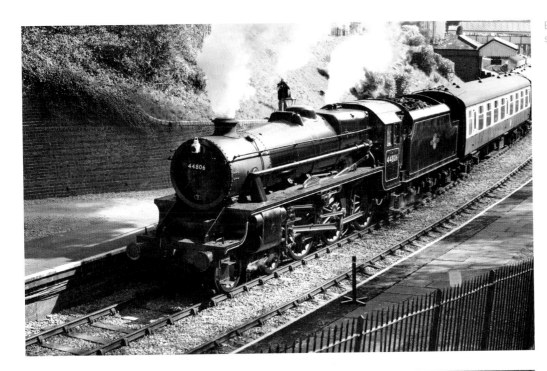

Black Five No. 44806 brings its train out of Llangollen station, North Wales.

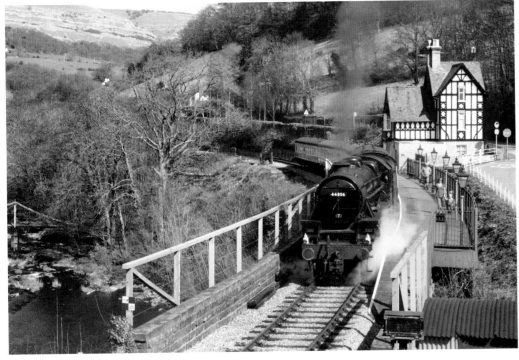

Black Five No. 44806 heads up-grade out of Berwyn station with the afternoon service. This is one of the classic views of the railway.

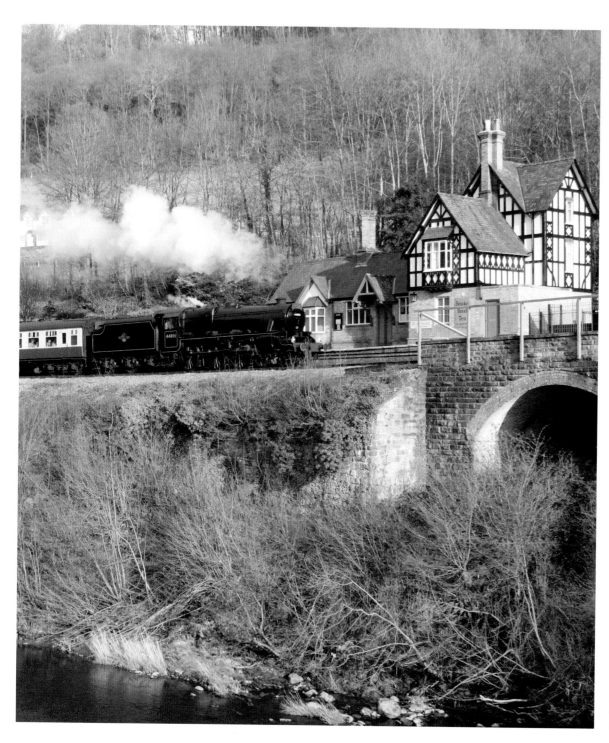

On an early summer's evening, the sunlight hits the north face of Berwyn station. This coincides with the passing of the non-stop Real Ale Special out of Llangollen. The LMS Black Five No. 44806 powers up and through the station maintaining a steady speed to give the appreciative drinkers a smooth ride.

STANDARD AGE

Standard Types

British Standard Variations produced from 1951

A total of 999 examples were produced. Designed by Robert Riddles who was, in all but name, the Chief Mechanical Engineer for British Railways. With Riddles being an ex-LMS man who worked under William Stanier, it came as no surprise that his engines were a development of that railway's designs. As well, there was a power classification, also incorporated from that railway, which classified locomotives according to their power on a grade from one to ten, with ten being the most powerful. The lowest British Standard type had a classification of two and then the rest followed. There were twelve BS types in all:

1 84xxx Class 2, 2-6-2T, based on Ivatt Class 2 tank. 30 built. None preserved. New example being created at Bluebell Railway using No. 78059 as a donor.

2 82xxx Class 3, 2-6-2T, tank version of the 77xxx type. 45 built. None preserved. New build ready at the Severn Valley Railway.

3 78xx Class 2, 2-6-0, Standard Ivatt Class 2 type. 65 built. 5 in preservation.

4 80xxx Class 3, 2-6-4T, the much-admired Fowler/Stanier/Fairburn design continued. 155 built. 15 in preservation.

5 77xxx Class 3, 2-6-0, for lightly laid routes. 20 built. All extinct.

6 76xxx Class 4, 2-6-0, based on the heavier Ivatt Class 4. 115 built. 4 in preservation. Tender incorporates back of cab.

7 75xxx Class 4, 4-6-0, introduced to replace the Manor Class of the GWR with the Cambrian coast route in mind. 80 built. 6 survive in preservation. Also a 4-6-0 76xxx version; 115 built with 4 preserved.

8 73xxx Class 5, 4-6-0, designed to complement the Black Five Class of the LMS. 172 built. Nos 73125–73154 had Capriotti valve gear fitted. 5 in preservation – Nos 73050, 73082, 73096, 73129 and 73156.

9 72xxx Clan, 4-6-2, a lighter version of the Britannia. 10 built (used mostly in Scotland). None survived. 1 new build under construction.

10 70xxx Britannia, 4-6-2 (2-cylinder) Class. 55 built. 2 preserved, No. 7000 *Britannia* and No. 70013 *Oliver Cromwell*.

11 The 71xxx, 4-6-2 (3-cylinder) Class (just 1 example). No. 71000, *Duke of Gloucester* preserved.

12 9F 92xxx 2-10-0 built for heavy freight but also used for passenger services. 251 built. 9 survive in preservation.

Although viewed with reservation when they first appeared in the early 1950s, enthusiasts now look upon these engines with great respect. Built at a time when other nations were turning to electric and diesel motion, it soon became apparent that this nation's reliance on its own coal would be short-lived and not the way forward. This, and the inability to attract enough people to do base jobs around the sheds, led the British Board to announce the complete transition to diesel in 1955. Within the next decade, all steam traction would be removed from the tracks of Britain's railways.

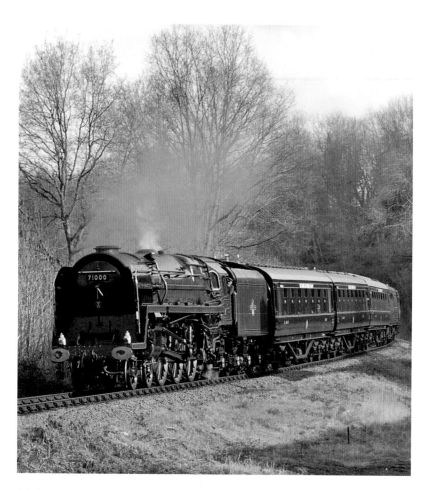

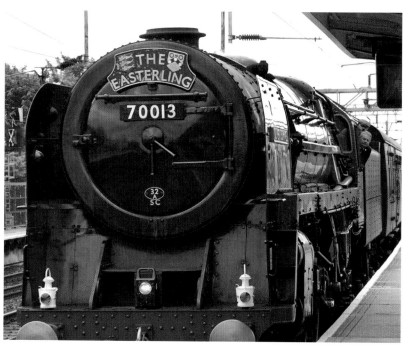

BR Britannia Class No. 70013 *Oliver Cromwell* arrives at Colchester with the Easterling rail tour. The Britannias were the flagship locomotives of the British Standard range, with No. 60003 *William Shakespeare* being exhibited at the Festival of Britain on London's South Bank in 1951.

BR Standard Class No. 71000 *Duke of Gloucester* approaches Highley station from the south on the Severn Valley Railway. This engine, built as a solitary class of one, has been one of the great successes of the preservation movement. When completed in 1954 the engine had steaming problems, which were never resolved. When the preservationists got hold of the engine from Barry scrapyard, they performed a complete rebuilding job, solving all the problems along the way.

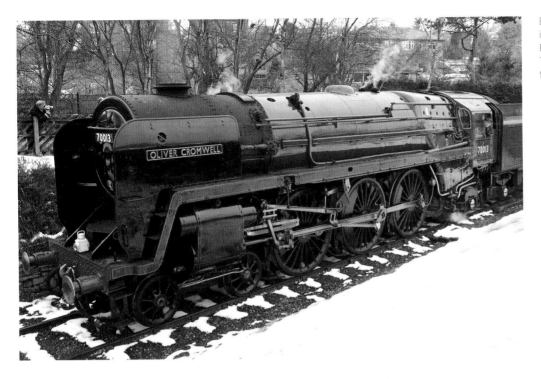

BR Britannia Class No. 70013 *Oliver Cromwell* pulls off its train at Oxenhope at the end of the Worth Valley Railway (K&WVR) – fifty-five of this class were built. This example was saved because it was active right up to the end of steam in 1968.

No. 73050 *City of Peterborough* prepares to take the next service out of Wansford station on the Nene Valley Railway. This railway uses extensive continental coaching stock, making it the perfect choice for when a film company needs a foreign scene. The BR Standard 5 4-6-0 was built in 1954 at Derby. This class was designed to supersede the Black Fives.

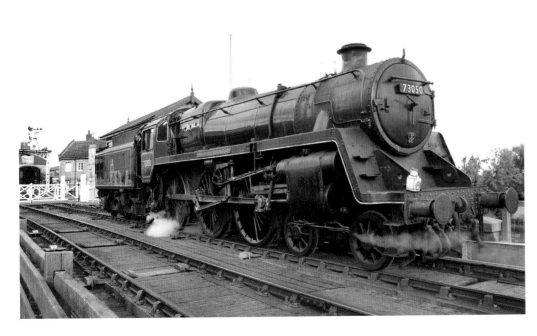

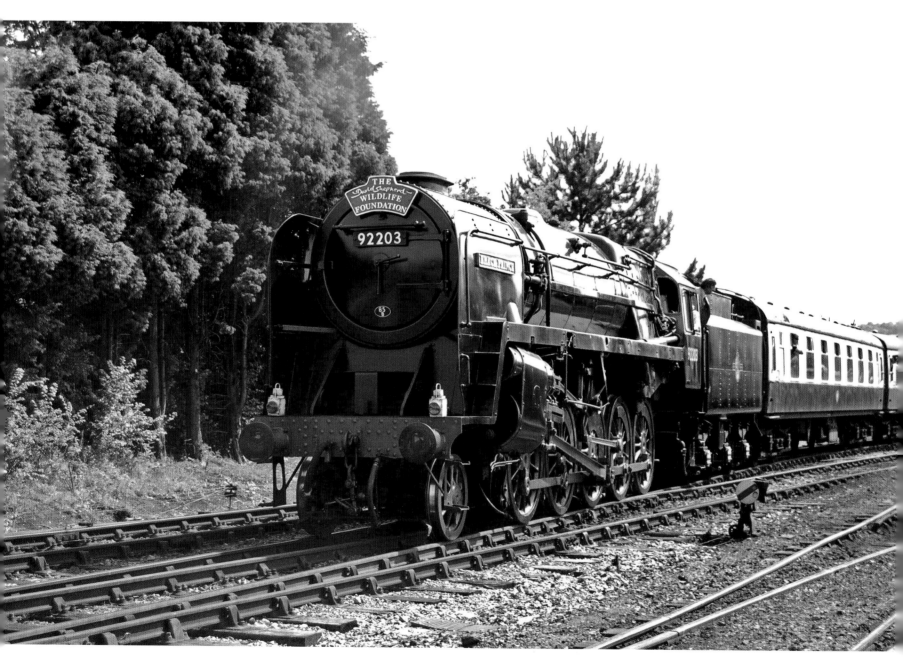

No. 92203 *Black Prince* brings a northbound train into Toddington station on the Gloucestershire Warwickshire Railway. The 9Fs were the most powerful freight locomotives to run in the UK and could be found throughout the country.

David Shepherd stands proudly with his charge. No. 92203 was purchased by David Shepherd straight out of British Railways service. The locomotive was named *Black Prince* during that year.

The courteous David Shepherd is always available to have a chat between runs with his engine. *Black Prince* celebrated its fiftieth birthday in 2009, with only five of those years spent in British Railways' service – a reminder of how little forethought went into the last days of steam traction in this country.

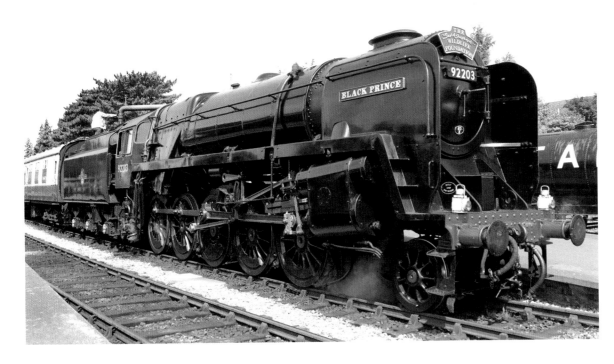

No. 92203 *Black Prince*, British Railways 9F Class, built at Swindon in 1959. Here, it makes a splendid sight standing proudly at the midway station of Winchcombe.

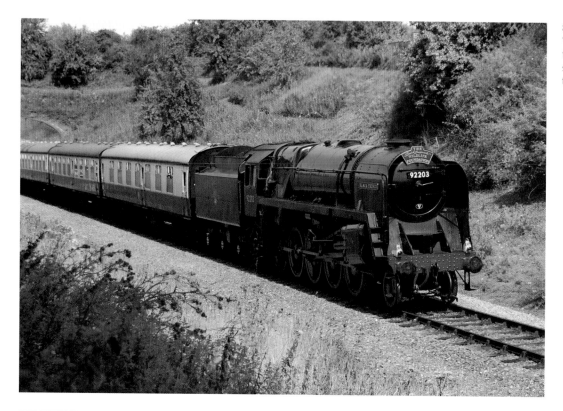

8F No. 92203 exits Greet tunnel and approaches Winchcombe station. David Shepherd purchased the locomotive straight out of British Railways service. The locomotive was named *Black Prince* in the preservation era.

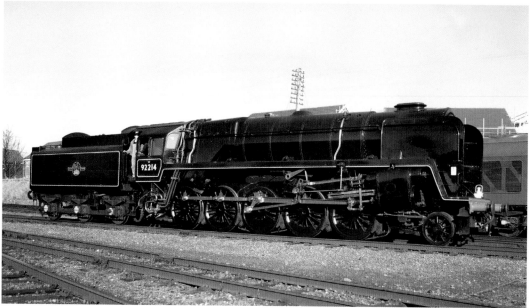

Another 9F engine. This time Riddles BR Standard 9F No. 92214 is in service at the Great Central Railway. How well turned out the engine is in its correct livery of lined black with the late BR crest on the tender. Young trainspotters liked to call these engines 'spaceships' back in the 1950s and '60s – it isn't hard to see why.

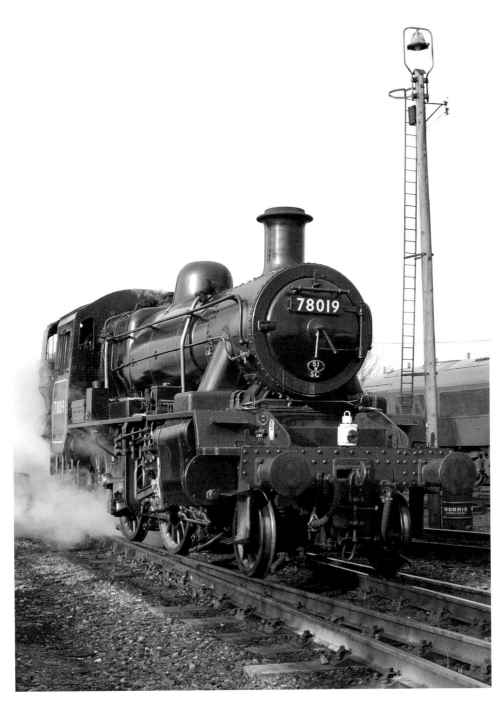

Another British Standard engine at the Great Central is British Standard Class 2, No. 78019, 2-6-0 wheel arrangement, coming into service at Loughborough. A very popular size of engine on a preserved railway where only the smaller loads are hauled.

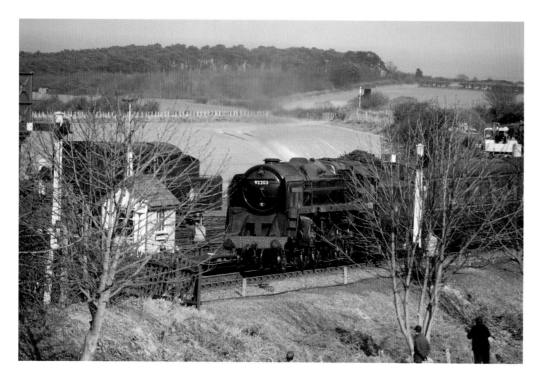

No. 92203 *Black Prince* has turned up at the North Norfolk Railway to provide the motive power on this testing stretch of line. On this early season gala the trains are long and full. Here the 9F comes into Weybourne station, the crossing point of the line for trains coming the other way.

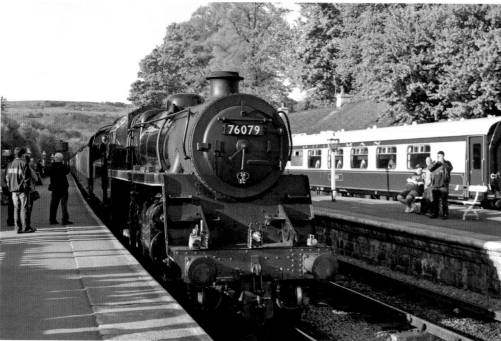

On a visit to Grosmont to the North York Moors Railway we find one of the stars of the main-line circuit in recent years. It is the Class 4 2-6-0 No. 76079, which earned the nickname of 'Pocket Rocket' due to its spirited runs across the country. The engine is proving useful here by using its main-line 'ticket' to make the National Network runs between Grosmont and Whitby.

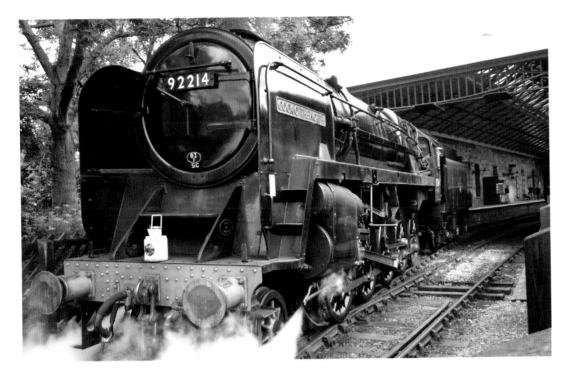

A view of Pickering station after the installation of the new roof, which was a magnificent facility to add to the comfort of staff and passengers. Backing into the station is BR Standard 9F No. 92214 which resided here for a few years and became a favourite. A name – *Cock o' the North* – was added but after its move south this was removed.

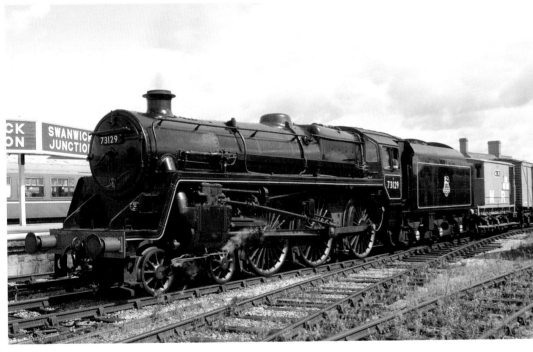

The Caprotti 5 Riddles Standard 5 waits at Swanwick station at the Midland Railway Centre. This engine was part of the last batch of thirty 5MTs to be built; these were fitted with Caprotti valve gear (rotary rather than sliding valve connectors) of which No. 73129 is the only survivor. BR Standard Class 5MT No. 73129 was built at Derby Locomotive Works in 1956, as part of a class designed to supersede the Black Fives.

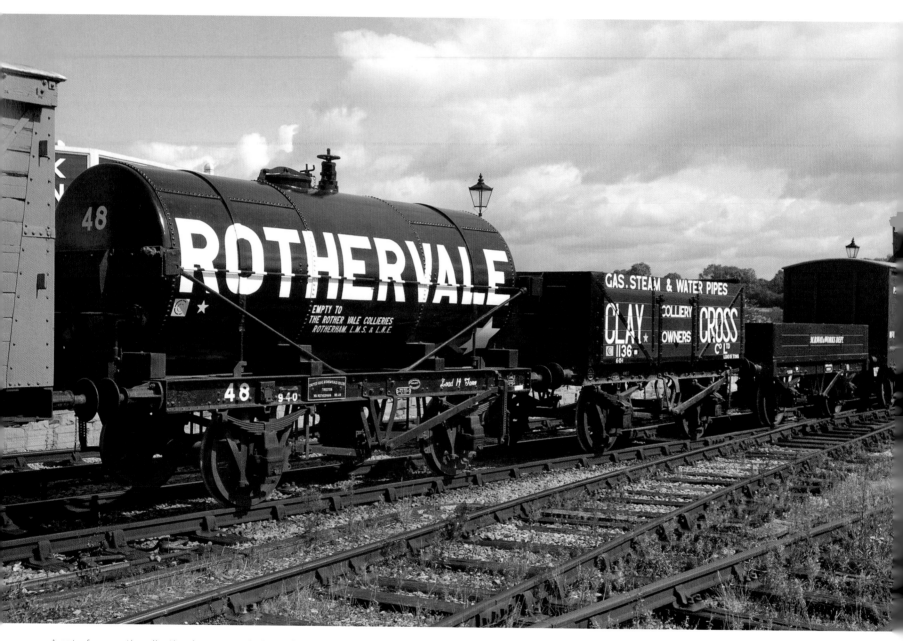

A set of pre-nationalisation loose-coupled goods wagons is shunted at Swanwick. This is surely one of the best sounds to be heard on a preserved railway, with the Midland Railway Centre providing one of the few locations where this can be heard.

MORAYSHIRE COMES SOUTH

How an Engine Works

The moving steam engine was the technological progression that superseded the horse. Low-pressure static steam engines had been developed for pumping water and pulling cables but it was Richard Trevithick who was to take the massive step forward to declare the advantages of high-pressure power. High-pressure steam has one great advantage, he realised, in that the size of the engine can be dramatically reduced. Those stationary beam engines had grown to enormous sizes. The size came down as well as the weight. Trevithick's portable machines had to run on a track. Wooden rails had been used for decades in the north-east of England for use by cable-drawn wagons, but these quickly deteriorated and would not be suitable for a single moving engine.

To develop his invention, Trevithick visited the Newcastle area in 1804 where industrialists were more than interested. So successful was the visit that the north-east of England became the area where most of the progress in the design and production of these engines took place over the following two decades. Here, they went from Trevithick's *Catch Me Who Can* to the *Rocket*. Trevithick's first moving engine worked on 4 pounds per square inch pressure (P.S.I.), which, at the time, was thought to be dangerous. To move a Bulleid Pacific, however, there needed to be something like 250 P.S.I.

Early steam engines worked to push a beam up and down in a simple back-and-forth or reciprocating motion. This was fine for pumping water out of a flooded mine, but was too heavy and inefficient for much else. A double-acting or counter-flow piston is more suited to rail use because it is driving the piston all the time. Steam pipes and valves enable steam to push a piston first one way and then the other. But steam has to be made and get to the pistons that drive the rods, which then turn the wheels.

The first part of the steam process happens in the firebox. This is where a fireman feeds the coal from the footplate. The firebox is surrounded by water spaces kept apart by stays, for this is where the pressure starts. The massive fire sends the gases and smoke upwards through the crown and into the long boiler. Stephenson devised a boiler full of water with tubes running through carrying the heat from the fire. This method was used until the end of steam on the railways.

The firebox construction is either steel or copper. A foundation ring at the base of the firebox supports the structure. In most fireboxes a sloping bridge of fire bricks, called the brick arch, partially separates the upper part of the firebox from the lower and helps the gases within the fire to mix before passing through the tubes. The arch also prevents the flames from striking the tubes too directly. Heat energy is provided by burning fuel, which then converts water to steam.

Underneath the fire grate is the ash pan, which collects any material that drops through and serves to control the supply of air under the fire by means of a damper. Through the tubes the gases pass from the firebox to the smokebox. The water inside the boiler eventually boils and, as it cannot escape, pressure inevitably builds up. The steam is then fed to the top where it gathers as saturated steam. Safety valves are designed to let steam escape automatically if the boiler pressure gets too high. Without water filling the boiler the fire's heat can weaken it, causing the pressurised boiler to explode.

The water gauge, or glass, is provided in the cab for the crew to monitor the water level. If the water level inside the boiler is allowed to fall too low, it also shows on the dial or goes out of sight on the gauge in the cab. If this happens, the crown sheet in the firebox would be uncovered. Mounted in this crown sheet are one or more fusible plugs, which would then melt and allow steam and water under pressure on to the fire, thus deadening the heat produced. Should this steam occur, the injector would be put on and steps taken to deaden further or remove the fire.

Inside the boiler, the pressurised (saturated) steam is at the top of the boiler where safety valves are sited to allow escape if the pressure gets too high. From the dome area steam passes through a regulator valve to pass into the feed tubes to the cylinders. Super-heated steam is added to this to provide intense steam pressure. Super-heating is simply an arrangement of tubing that conducts the steam back through extra-large flues, where it is heated to a higher temperature. This development came into general use around 1910.

Cylinders with pistons can be positioned to each side of the engine, or between the wheels (known as inside cylinders). The cylinders are supplied out of phase, so the engine can start from any wheel position. The valve system then allows high-pressure steam to act alternately on both faces of the piston. So, in fact, steam action pushes each piston in both directions. Hence, on a three-cylinder locomotive there are six exhaust beats to every full turn of a driving wheel.

Walschaerts valve gear has proved to be the most popular system of opening and closing the valve ports. This process lets steam into each end of the piston to be controlled, as well as allowing the exhaust gases to be expelled. The driver works the valve gear with the reverser lever, so named because it is used to control the locomotive's direction of travel as well as the gearing of valve procedures. When a locomotive is stationary, the driver will need to operate a blower to enable gases to pass onwards, which the motion of the engine ordinarily does whilst in motion. Any change of reverser setting will alter the positions of the connecting rod, as can be seen on the sides of an engine.

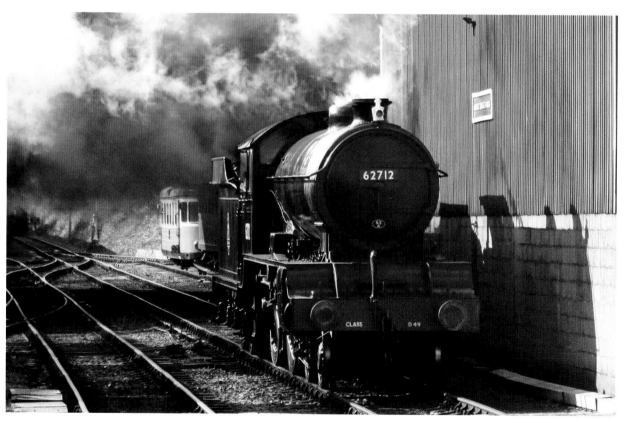

A visitor from Scotland makes a double visit in East Anglia. Here, at Wansford on the Nene Valley Railway, former LNER D49 4-4-0 No. 62712 *Morayshire* makes the first appearance. The engine is sporting the early British Railways livery of lined black showing the lion and wheel emblem. Having taken water, the engine runs around to head the return train to Peterborough.

In the BR mixed-traffic livery of lined shiny black, No. 62712 *Morayshire* makes a big impression passing through to run around its train. The current owners of the engine are the National Museum of Scotland and the Scottish Railway Preservation Society, who made this visit possible.

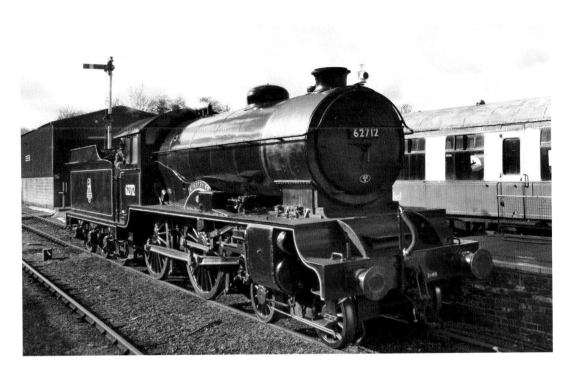

The crossing gates are being opened by a wheel in the sixty-frame signal box at Wansford. This indicates the size the siding complex must have been here and, with this being the original A1 road, it must have been a site of much action, and hold ups. The engine crew are at the ready and soon the starter signals will be pulled off.

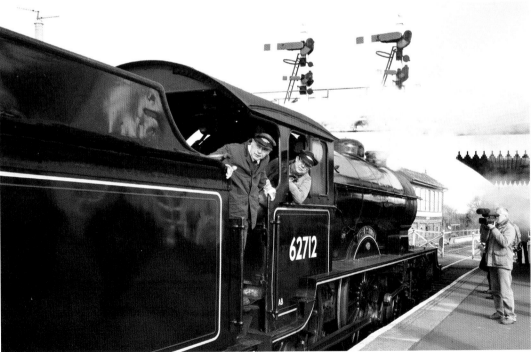

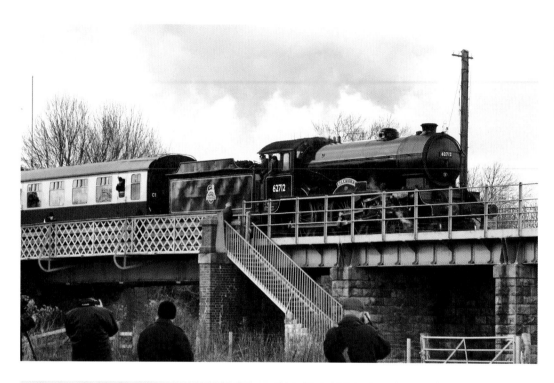

The compact engine powers away eastwards from Wansford. Class D49 No. 62712 (LNER 276) *Morayshire* quickly picks up speed with a loaded train. Built at Darlington in 1928 and then allocated to Dundee shed, Gresley named the class after shires and hunts. A field full of photographers are recording every move.

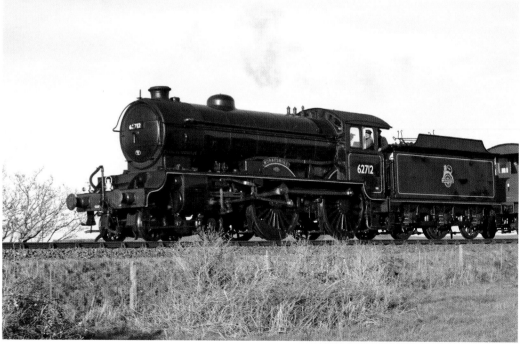

After Peterborough, the 4-4-0 *Morayshire* has made the journey across East Anglia to Sheringham to make a star appearance at the early season gala of the North Norfolk Railway. Taking timetabled services, the three-cylindered loco also pulled some demonstration goods trains. Here it tops the rise out of Sheringham on one such run.

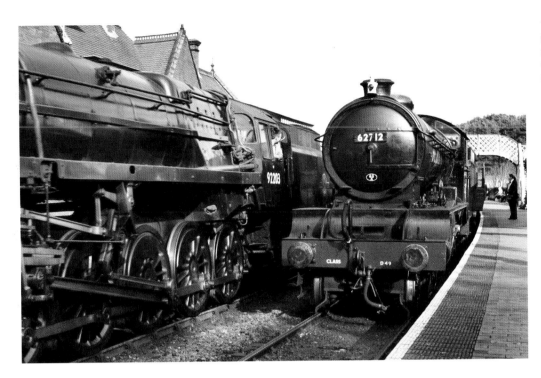

The guest engine waits in the platform at Weybourne to allow 9F No. 92203 *Black Prince* to bring in its train. This busy point in the line creates much interest, with trains crossing and demonstration freights being formed and taken out from the shed area.

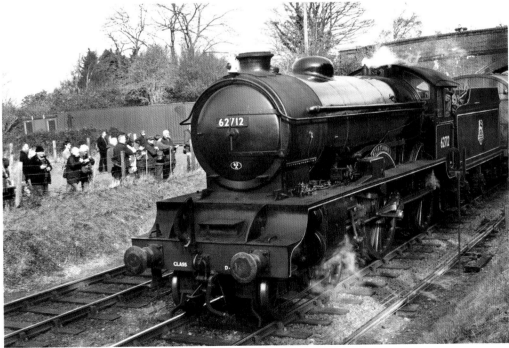

The road is now clear for No. 62712 to take its train forward for the last leg of the journey, Holt being the final station. The line is a preserved section of the old 'Muddle and Get Nowhere', the Midland & Great Northern Joint Railway.

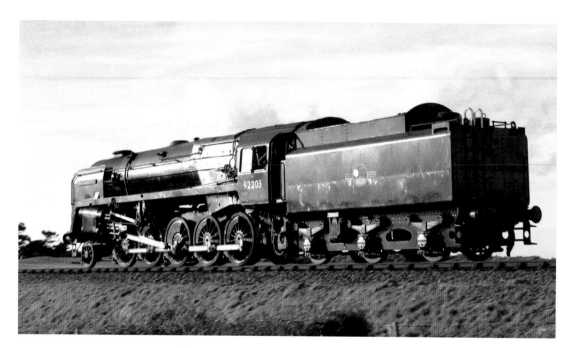

Other attractions for the North Norfolk Railway's gala event are completing the cast. At the high point of the line outside Sheringham, British Standard 9F No. 92203 *Black Prince* (now part of North Norfolk Railway's home fleet) moves between stations to take up position to head the next service.

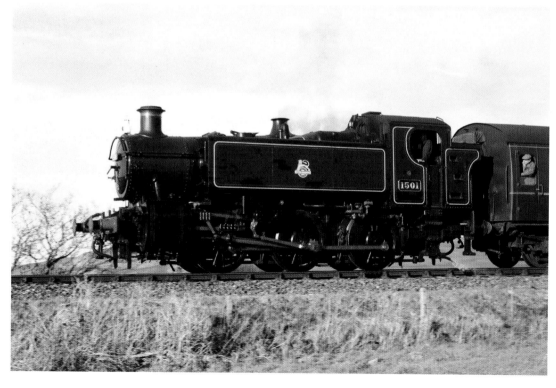

At the same location visiting GWR (WR) Pannier tank 0-6-0PT No. 1501 makes short work of the gradient to power onwards towards Weybourne. The engine should be strong, as it was designed to pull full-length empty stock out of Paddington station.

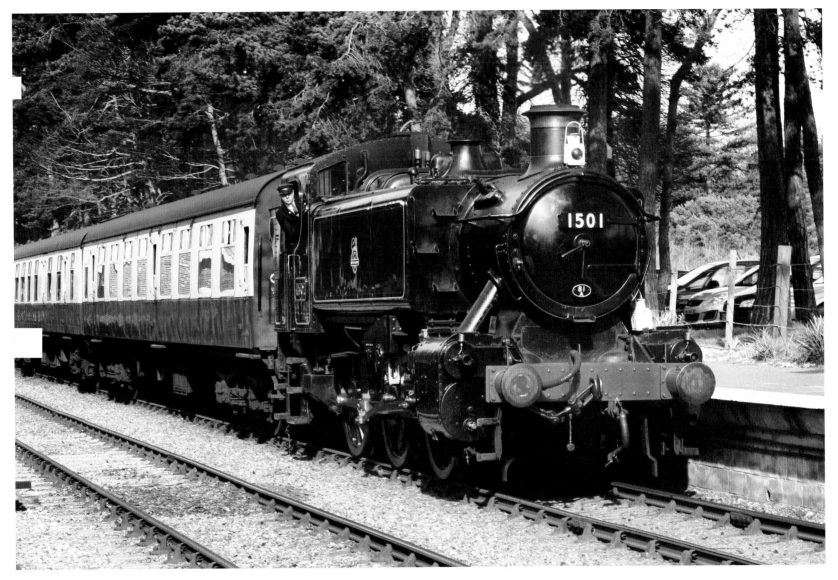

A different time and a different set of carriages, the Hawksworth Pannier tank (built 1949) No. 1501 arrives at Holt station to complete its journey.

Moving in towards Weybourne station is resident engine, the celebrated B12, 2-6-0, BR No. 61572.

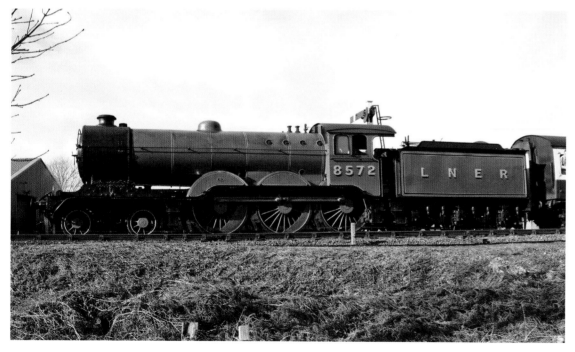

B12, No. 61572 moves forward to show us the very closely coupled six set of driving wheels and a little tender – A Gresley rebuild of a previous class in 1928 with a larger boiler. Holden designed the original loco, which in his time had just a four-coupled driving set.

ELEVEN

MAUNSELL TO THE ECCENTRIC BULLEID

Bulleid Takes Over

The Southern Railway always thought of itself as the poor relation of the other Big Four railways. These were the companies who were formed after the 'grouping' in 1923, when the railways were merged into four large companies following the First World War. The Southern didn't have the long-distance routes like the others except for the lines from London to Devon and Cornwall, and, in effect, these duplicated those of the GWR. The GWR was generally thought to have the upper hand in servicing this corner of the country. The Southern was left with short-hop routes from London to the south coast.

Maunsell was the Chief Mechanical Engineer from around the mid 1920s. His ambitions were limited owing to the ever-growing electrification of the region, which left him developing old designs from the Southern Railway's constituents. With the demand being for mid-range engines, he largely favoured the wheel arrangement 2-6-0, which became known as Maunsell Moguls. Upon his retirement in 1937, however, the Southern's management realised that there was a need for the introduction of some heavier duty locomotives to head the prestige expresses for the ever-growing numbers of passengers. These heavy-duty engines would also be needed to haul the boat trains to and from the southern ports, especially Southampton. A new Chief Mechanical Engineer was required and, when one particular name came forward, the directors immediately knew that he would fit the bill. His name

was Oliver Bulleid, a previous assistant to Sir Nigel Gresley (of the LNER) for a number of years.

After the interview and formalities, Bulleid was appointed to the position. But in the not too distant future the realities of the time came to the fore – war was looming. A Ministry of Supply had been formed to assess the expected transportation needs of the country in times of hostilities. It became immediately apparent that the prime need was for engines to haul huge volumes of freight traffic and heavy passenger trains.

This aggrieved Bulleid, who had laid down plans for a new class of express passenger engines – one that would not only have the Pacific wheel arrangement of 4-6-2, but also be of revolutionary design and bear his name as designer. Not to be deterred, he continued with this new class, but classified them as mixed-traffic engines. In 1941 the first example came into service, soon followed by a further nine – with full publicity and all immediately allocated to express passenger use. Building a further ten in 1945, he followed these up by introducing a smaller, lighter version for use on the West Country routes west of Exeter. Bulleid got so carried away with the impact his Pacifics created that he continued the production until 140 examples had been manufactured – an over production in the extreme since the lighter Nelsons and King Arthurs could easily have coped with the West Country services. When running beyond Exeter, the trains had to split and split again, with the

effect that at the ends of branch lines, to such places as Bude and Padstow, one of Bulleid's Pacifics could be seen pulling just one carriage.

By a quirk of geography, a large number of the Bulleids ended up at the Woodham Brothers scrapyard in South Wales, and hence became favourites for restoration. This has left us with twenty of the Light Pacifics and fifteen Merchant Navy locomotives in our system, of which about three-quarters are back in running order. The Bulleid legend lives on.

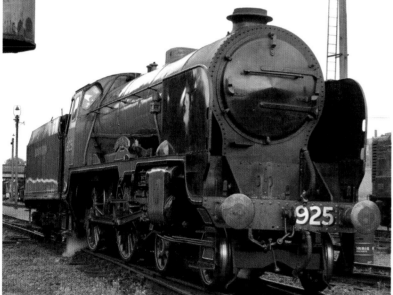

The three-cylindered Southern Railway 'Schools' Class No. 925 *Cheltenham* was one of the class of most powerful 4-4-0 locomotives in Britain. They were named after public schools in the south of England. The 'Schools' locomotive has a turn of duty at the Great Central Railway and is here seen at the watering point at Loughborough.

The only surviving example of the Urie-designed N15, later to be called *King Arthur*. Taken further by Maunsell for the Southern Railway to be used for express passenger work. No. 30777 *Sir Lamiel* is seen here outside the Loughborough Works. Built by NBL Co. Ltd, Scotland, in 1925.

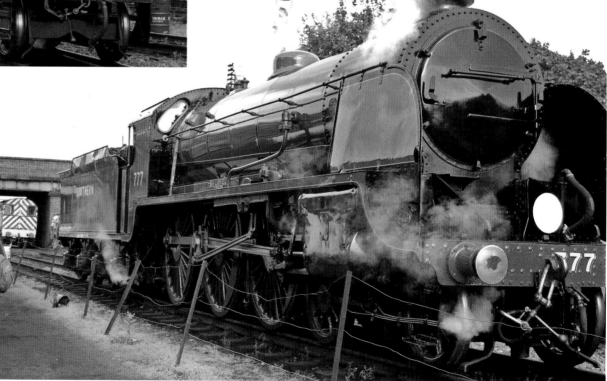

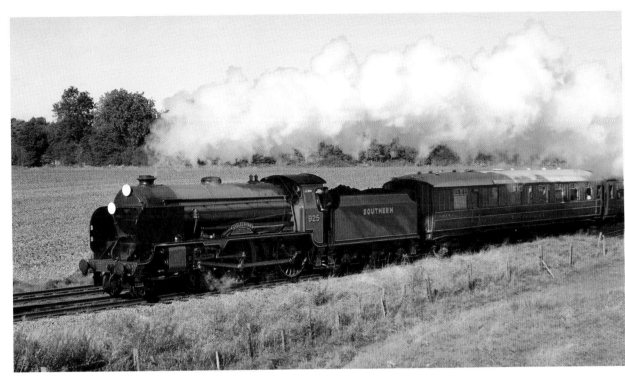

'Schools' Class No. 925 *Cheltenham* runs free in the country south of Loughborough. Introduced in 1934, these engines were designed to cope with the severe width restrictions of the Mountfield and Bo-Peep tunnels on the Hastings line. The three cylinders give the engine six beats to a revolution of the driving wheels because the cylinder is double acting and the valve gear is designed to push and pull the piston.

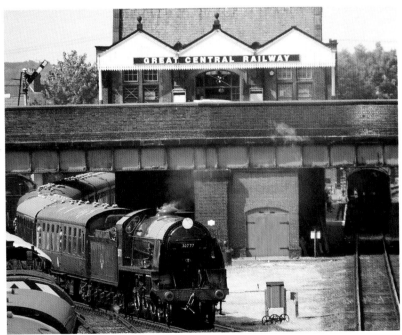

No. 30777 *Sir Lamiel* picks up speed coming out of Loughborough. This engine is part of the National Collection.

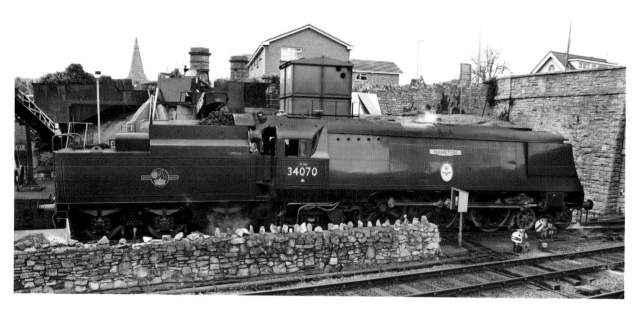

The Battle of Britain Pacific 4-6-2 No. 34070 *Manston* prepares to move away from the coaling area. This picture is taken from the viewing gallery opposite the Swanage shed and turntable. The Battle of Britain engines are exactly the same as the West Country Class of the same design, except for the nameplates. Many were to lose their air-smoothed casing.

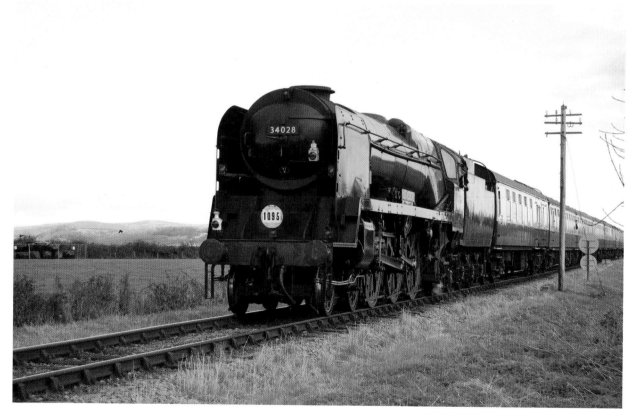

Here is an example of a Bulleid Pacific which did lose its air-smoothed casing. The rebuilt Bulleid Pacific West Country Class No. 34028 *Eddystone* approaches Dunster station from the east on the West Somerset Railway. Eddystone is a lighthouse guarding the bay off Plymouth Sound. This is an example of how this class was named after towns and landmarks in the west of England.

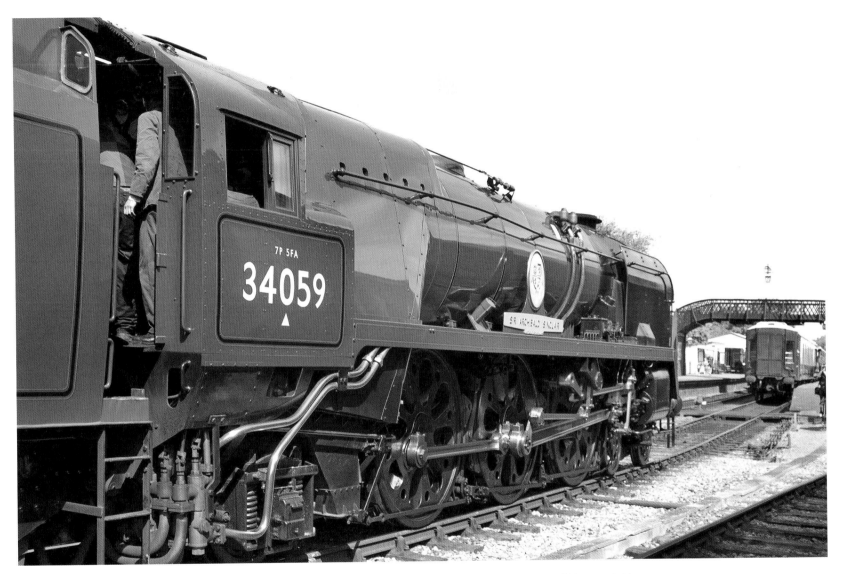

Battle of Britain Class No. 34059 *Sir Archibald Sinclair* moves forward to head the Pullman train in Horsted Keynes station.

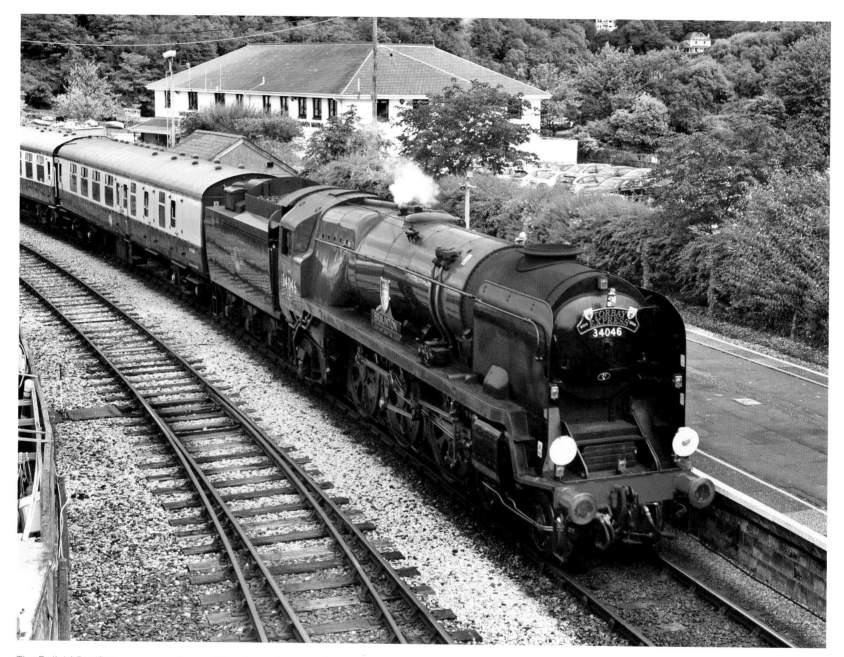

The Bulleid Pacifics are very active working steam tours on the main line. Here we see a reconstruction of the GWR Torbay Express, which arrived daily at this destination from London's Paddington station. The train is headed by the rebuilt Bulleid Pacific No. 34046 *Braunton*. Today the train started out from Bristol.

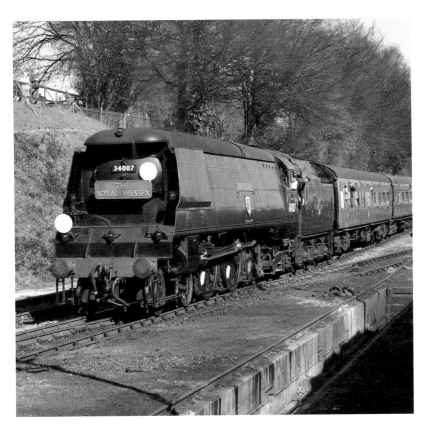

Resident at the Mid Hants Railway, West Country Pacific No. 34007 *Wadebridge* brings a westbound service into Ropley station – an example of the class which escaped being stripped of its casing.

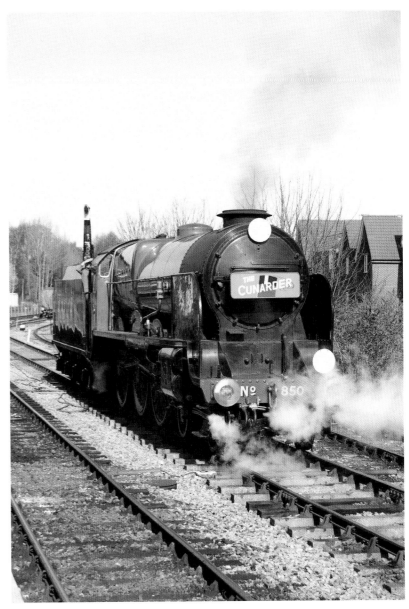

Four-cylindered No. 850 *Lord Nelson* with head-plate, the *Cunarder* waits at Alton to make the return trip. Celebrating the shipping line, the name represents the notable boat train, which ran from London's Waterloo station to the Southampton Ocean Terminal. The class of sixteen were all named after naval commanders.

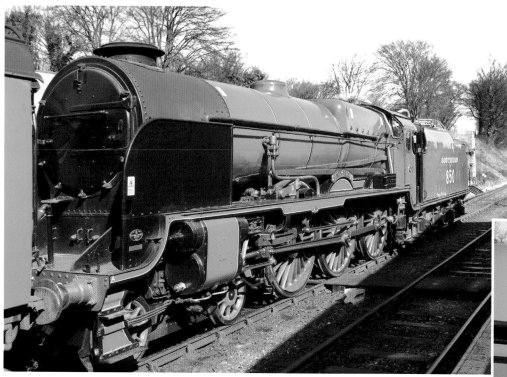

Once considered the most powerful 4-6-0 locomotive in Britain, the four-cylindered motion of *Lord Nelson* has a sound beat all of its own. Introduced by Maunsell in 1926, the claim was that these outstripped the Castles of the GWR. Swindon countered this by introducing a more powerful type called the Kings.

The nameplate of No. 850 *Lord Nelson* shines out over O.V. Bulleid's favourite livery, malachite green.

ON THE MAIN LINE

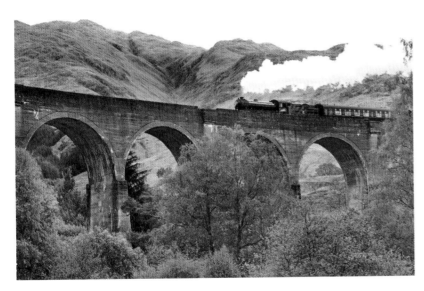

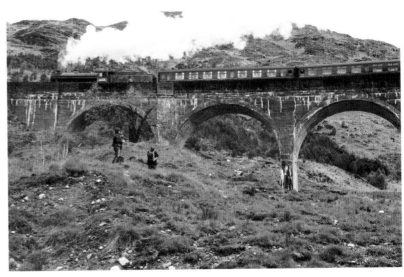

In Scotland: The Jacobite, running from Fort William to Mallaig, is one of the very few timetabled steam services still operating. The train passes over several concrete viaducts, the most notable being the twenty-one-arch structure at Glenfinnan. The bridge was built in 1898 using new technology incorporating unreinforced concrete. The builder was Robert McAlpine, the founder of the famous construction company, who got the nickname 'Concrete Bob'.

The train passing over the curving Glenfinnan Viaduct is headed by K1 2-6-0 No. 62005.

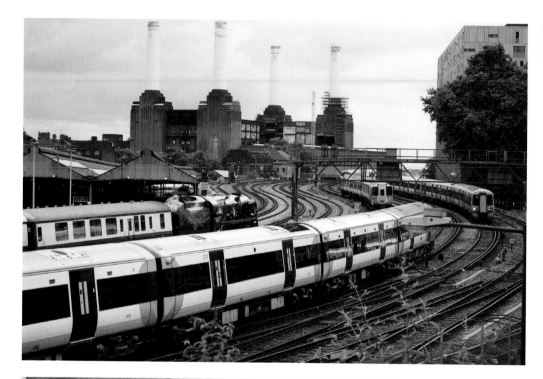

Bulleid-rebuilt Merchant Navy Class *Clan Line* takes the Orient Express Pullman away from Victoria station along one of the busiest stretches of line in the country.

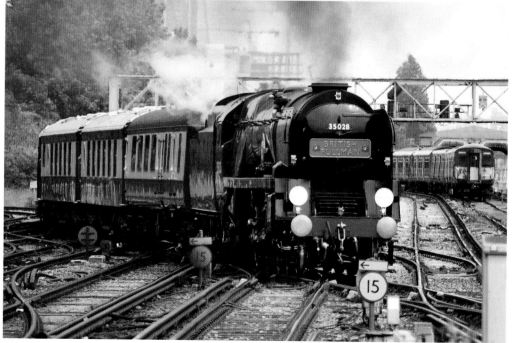

The Merchant Navy Class *Clan Line* No. 35028 arrives at Clapham Junction with the lunchtime special **Orient Express**.

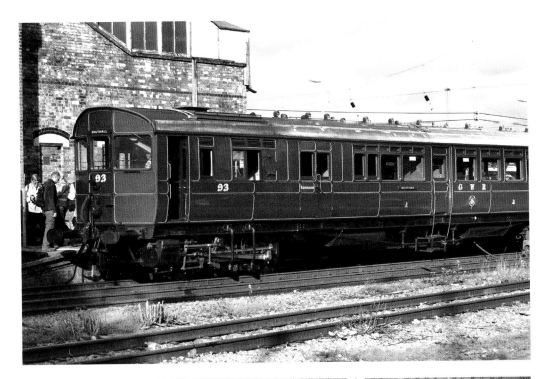

The new power unit for steam railmotor No. 93 was built at Bradford and installed at Llangollen. On this day, the self-propelled railcar is operating between Southall and Brentford – where it first operated in 1908. A bunker on the train can hold about 3cwt of coal and a tank holds 450 gallons of water.

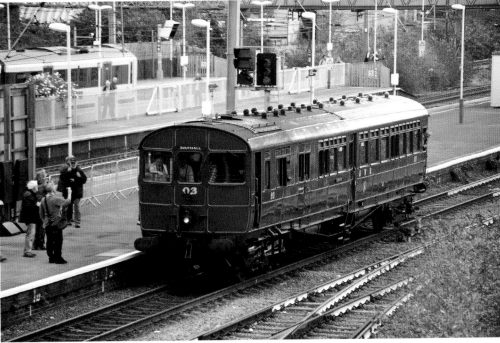

Railmotor No. 93 makes headway towards Brentford along familiar ground. This time it is acting alone, although there is often an auto-trailer with it. The large saloon-type carriages must have made a good change from the normal suburban carriages of the time.

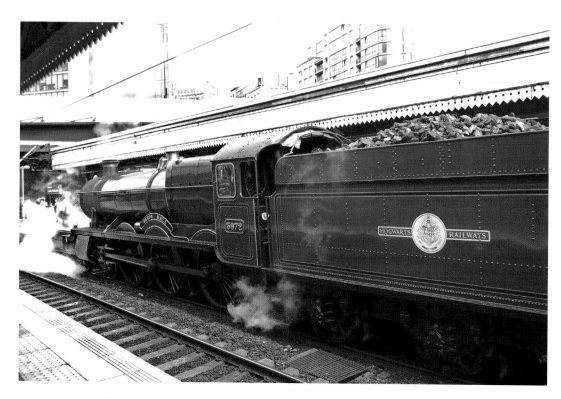

No. 5972 GWR Hall Class *Olton Hall* in special maroon livery for the film *Harry Potter and the Philosopher's Stone* has found a new life as a film star. Here awaiting departure at Paddington station for a special for all those Harry Potter enthusiasts.

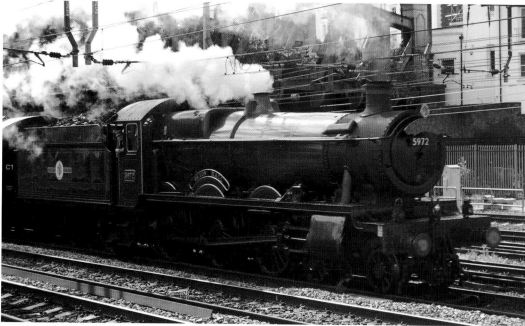

The 'Hogwarts Railway' powers away from Paddington station passing Royal Oak.

B1 Class No. 1306 (BR 61306) *Mayflower* heads a rail tour from London to Norwich, and back. Norwich is a useful destination because there is a triangle of lines just outside which is convenient for turning the engine around. This time there was a problem because the triangle was loaded with sets of carriages.

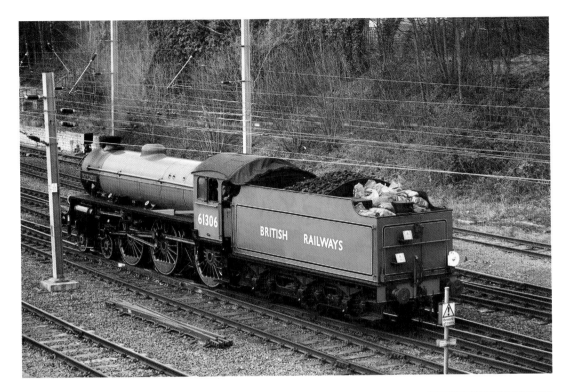

It proved, on this occasion, that there could be no turning of the engine. Here we see the train passing away towards the east, where a successful turning could be made – at Lowestoft.

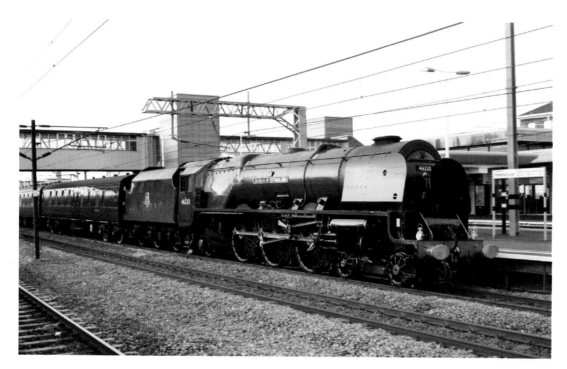

A rail tour in the summer of 2014 saw the final leg between York and King's Cross being led by a railway classic. In BR Brunswick green livery, No. 46233 *Duchess of Sutherland* arrives at Peterborough. Designed by Sir William Stanier and built at Crewe Works in July–August 1938, this is only one of three of the class that have survived into preservation.

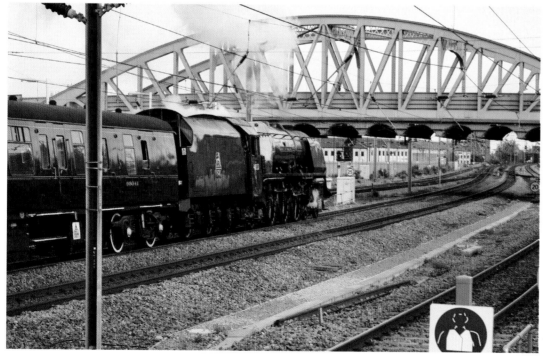

No. 46233 *Duchess of Sutherland* pulls away from Peterborough station to pass under the steel girder viaduct.

APPENDIX 1

WHEEL ARRANGEMENTS

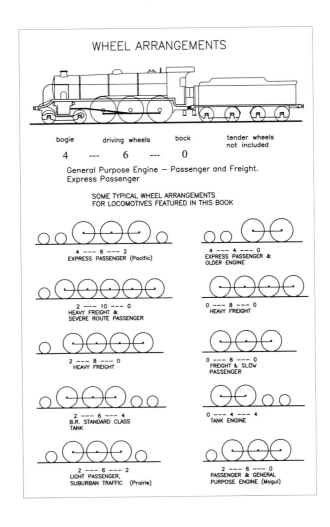

STEAM GUIDE (STANDARD GAUGE)

ALDERNEY RAILWAY
Alderney, Channel Islands
www.alderneyrailway.com
Tel: 01455 634373

AVON VALLEY RAILWAY
Bitton Station, Nr Bristol, BS30 6HD
www.avonvalleyrailway.org.uk
Tel: 01457 484950

BARROW HILL ROUNDHOUSE
Chesterfield, Derbyshire, S43 2PR
www.barrowhill.org.uk
Tel: 01246 472450

BARRY TOURIST RAILWAY
Station Approach Rd, Barry, CF62 5TH
www.barrytouristrailway.co.uk
Tel: 01446 748816

BATTLEFIELD LINE RAILWAY
Shackerstone Station, CV13 6NW
www.battlefield-line-railway.co.uk
Tel: 01827 880754

BLUEBELL RAILWAY
Sheffield Park Station, TN22 3QL
Horsted Keynes Station, RH17 7BB
www.bluebell-railway.co.uk
Tel: 01825 720800

BODMIN & WENFORD RAILWAY
Bodmin General Station. PL31 1AQ
www.bodminrailway.co.uk
Tel: 01208 73666

BO'NESS & KINNEIL RAILWAY
Bo'ness Station, EH51 9AQ
www.bkrailway.co.uk
Tel: 01506 825855

BOWES RAILWAY CENTRE
Gateshead, NE9 7QJ
www.newcastlegateshead.com
Tel: 01914 161847

BRESSINGHAM STEAM MUSEUM
Nr Diss, Norfolk, IP22 2AA
www.bressingham.co.uk
Tel: 01379 686900

BRISTOL HARBOUR RAILWAY
Princes Wharf, BS1 4RN
www.bristolharbourrailway.co.uk
Tel: 01173 526600

BUCKINGHAM RAILWAY CENTRE
Quainton Road Station, HP22 4BY
www.bucksrailcentre.org.uk
Tel: 01296 655720

CALEDONIAN RAILWAY
Brechin Station, DD97AF
www.caledonian-railway.com
Tel: 01356 622992

CHASEWATER RAILWAY
Brownhills West, WS8 7NL
www.chasewaterrailway.co.uk
Tel: 01543 452623

CHINNOR & PRINCES RISBOROUGH RAILWAY
Chinnor Station, OX39 4ER
www.chinnorrailway.co.uk
Talking Timetable: 01844 353535

CHOLSEY & WALLINGFORD RAILWAY
Wallingford, OX10 9GQ
www.cholsey-wallingford-railway.com
Tel: 01491 835067

CHURNET VALLEY RAILWAY
Kingsley & Froghall Station, ST10 2HA
www.churnet-valley-railway.org.uk
Tel: 01538 750755

COLNE VALLEY RAILWAY
Hedingham Castle, CO9 3DZ
www.colnevalleyrailway.co.uk
Tel: 01787 461174

DARLINGTON RAILWAY MUSEUM
Station Rd, Darlington, DL3 6ST
www.darlington.gov.uk
Tel: 01325 460532

DARTMOOR RAILWAY
Oakhampton, EX20 1EJ
www.dartmoorrailway.com
Tel: 01837 55164

DARTMOUTH STEAM RAILWAY
& RIVER BOAT COMPANY
Paignton, TQ4 6AF
www.dartmouthrailriver.co.uk
Tel: 01803 555872

DEAN FOREST RAILWAY
Lydney, GL15 4ET
www.deanforestrailway.co.uk
Tel: 01594 845840

DERWENT VALLEY LIGHT RAILWAY
Murton Park, York, YO19 5UF
www.dvlr.org.uk
Tel: 01904 489966

DIDCOT RAILWAY CENTRE
Didcot, OX11 7NJ
www.didcotrailwaycentre.org.uk
Tel: 01235 817200

DOWNPATRICK & CO. DOWN RAILWAY
Downpatrick Station, BT30 6LZ
www.downrail.co.uk
Tel: 02844 612233

EAST ANGLIAN RAILWAY MUSEUM
Chappel, Nr Colchester, CO6 2DS
www.earm.co.uk
Tel: 01206 242524

EAST KENT RAILWAY
Shepherdswell, CT15 7PD
www.eastkentrailway.co.uk
Tel: 01304 832042

EAST LANCASHIRE RAILWAY
Bury Bolton Street Station, BL9 0EY
Rawtenstall Station, BB4 6DD
Ramsbottom Station, BL0 9AL
www.eastlancsrailway.org.uk
Tel: 01617 647790

EAST SOMERSET RAILWAY
Cranmore Station, BA4 4QP
www.eastsomersetrailway.co.uk
Tel: 01749 880417

ECCLESBOURNE VALLEY RAILWAY
Wicksworth, DE4 4FB
www.e-v-r.com
Tel: 01629 823076

ELSECAR HERITAGE RAILWAY
Elscar Heritage Centre, S74 8HJ
www.elsecarrailway.co.uk
Tel: 01226 740203

EMBSAY & BOLTON ABBEY STEAM
RAILWAY
Bolton Abbey Station, Skipton, BD23 6AF
www.embsayboltonabbeyrailway.org.uk
Tel: 01756 710614
Talking Timetable: 01756 795189

EPPING-ONGAR RAILWAY
Ongar Town, CM5 9AB
www.eorailway.co.uk
Tel: 01277 365200

FOXFIELD STEAM RAILWAY
Blythe Bridge, ST11 9BG
www.foxfieldrailway.co.uk
Tel: 01782 396210

GLOUCESTERSHIRE WARWICKSHIRE
RAILWAY
Toddington Station, GL54 5DT
Winchcombe Station, GL54 5LB
www.gwsr.com
Tel: 01242 621405

GREAT CENTRAL RAILWAY
Loughborough Central Station, LE11 1RW
Quorn & Woodhouse, LE12 8AW
Leicester North, LE4 3BR
www.gcrailway.co.uk
Tel: 01509 632323

GREAT CENTRAL RAILWAY,
NOTTINGHAM
Ruddington, NG11 6JS
www.gcrn.co.uk
Tel: 0115 9405705

GWILI RAILWAY
Carmarthen, SA33 6HT
www.gwili-railway.co.uk
Tel: 01267 230666

GWR (STEAM MUSEUM)
Swindon, SN2 2EY
www.steam-museum.org.uk
Tel: 01793 466646

ISLE OF WIGHT STEAM RAILWAY
Havenstreet, PO33 4DS
www.iwsteamrailway.co.uk
Tel: 01983 882204

KEIGHLEY & WORTH VALLEY RAILWAY
Haworth Station, BD22 8NJ
Keighley Station, BD21 4HP
www.kwvr.co.uk
Tel: 01535 645214

KENT & EAST SUSSEX RAILWAY
Tenterden Station, TN30 6HE
www.kesr.org.uk
Tel: 01580 765155
Talking Timetable: 01580 762943

LAKESIDE & HAVERTHWAITE RAILWAY
Haverthwaite Station, LA12 8AL
www.lakesiderailway.co.uk
Tel: 01539 531594

LAVENDER LINE
Isfield Station, TN22 5XB
www.lavender-line.co.uk
Tel. 01825 750515

LINCOLNSHIRE WOLDS RAILWAY
Ludborough, DN36 5SH
www.lincolnshirewoldsrailway.co.uk
Tel: 01507 363881

LLANGOLLEN RAILWAY
Llangollen Station, LL20 8SN
www.llangollen-railway.co.uk
Tel: 01978 860979

MANGAPPS FARM RAILWAY MUSEUM
Burnham-on-Crouch, CM0 8QG
www.mangapps.co.uk
Tel: 01621 784898

MIDDLETON RAILWAY
Hunslet, LS10 2JQ
www.middletonrailway.org.uk
Tel: 0845 680 1758

MID HANTS RAILWAY
(WATERCRESS LINE)
Railway Station, Alresford, SO24 9JG
Ropley Station, SO24 0BL
www.watercressline.co.uk
Tel: 01962 733810

MIDLAND RAILWAY CENTRE
Butterley Station, DE5 3QZ
Swanwick Junction
www.midlandrailwaycentre.co.uk
Tel: 01773 570140

MID-NORFOLK RAILWAY
Dereham Station, NR19 1DF
www.mnr.org.uk
Tel: 01362 851723

MID-SUFFOLK LIGHT RAILWAY
Wetheringsett, IP14 5PW
www.mslr.org.uk
Tel: 01449 766899

NATIONAL RAILWAY MUSEUM
Leeman Road, York, YO26 4XL
www.nrm.org.uk
Tel: 08448 153139

NENE VALLEY RAILWAY
Wansford Station, PE8 6LR
www.nvr.org.uk
Tel: 01780 784444

NORTHAMPTON & LAMPORT RAILWAY
Pitsford & Brampton Station, NN6 8BA
www.nlr.org.uk
Tel: 01604 820327

NORTHAMPTONSHIRE IRONSIDE
RAILWAY TRUST
Northampton, NN4 9UW
www.nirt.co.uk
Tel: 01604 702031

NORTH NORFOLK RAILWAY
Sheringham Station, NR26 8RA
Holt Station, NR25 6AJ
www.nnrailway.co.uk
Tel: 01263 820800

NORTH TYNESIDE STEAM RAILWAY
(Stephenson Railway Museum)
North Shields, NE29 8DX
www.twmuseums.org.uk

NORTH YORK MOORS RAILWAY
Pickering, YO18 7AJ
Goathland, YO22 5NF
Grosmont, YO22 5QE
www.nymr.co.uk
Tel: 01751 472508

PALLOT STEAM, MOTOR & GENERAL
MUSEUM
Jersey, Channel Islands
www.pallotmuseum.co.uk
Tel: 01534 865307

PEAK RAIL
Matlock, DE4 3NA
www.peakrail.co.uk
01629 580381

PLYM VALLEY RAILWAY
Plympton, PL7 4NW
www.plymrail.co.uk

PONTYPOOL & BLAENAVON RAILWAY
Blaenavon, NP4 9ND
www.pontypool-and-blaenavon.co.uk
Tel: 01495 792263

RAILWAY PRESERVATION SOCIETY OF
IRELAND
www.steamtrainsireland.com

RUTLAND RAILWAY MUSEUM
Cottesmore, LE15 7BX
www.rutnet.co.uk
Tel: 01572 813203

SEVERN VALLEY RAILWAY
Bridgnorth, WV16 5DT
Bewdley, DY12 1BG
Kidderminster. DY10 1QX
www.svr.co.uk
Tel: 01299 403816

SOUTH DEVON RAILWAY
Buckfastleigh, TQ11 0DZ
www.southdevonrailway.co.uk
Tel: 0843 357 1420

SOUTHALL RAILWAY CENTRE
Southall, UB2 4SE
www.gwrpg.co.uk
Tel: 0208 574 1529

SPA VALLEY RAILWAY
Tunbridge Wells, TN2 5QY
www.spavalleyrailway.co.uk
Tel: 01892 537715

STRATHSPEY RAILWAY
Aviemore, PH22 1PY
www.strathspeyrailway.co.uk
Tel: 01479 810725

SWANAGE RAILWAY
Swanage, BH19 1HB
www.swanagerailway.co.uk
Tel: 01929 425800

SWINDON & CRICKSLADE STEAM
RAILWAY
Blunsdon, Wiltshire
www.swindon-crickslade-railway.org.uk
Tel: 01793 771615

TANFIELD RAILWAY
Gateshead, NE16 5ET
www.tanfield-railway.co.uk
0845 463 4938

TELFORD STEAM RAILWAY
Horsehay, TF4 2NG
www.telfordsteamrailway.co.uk

TYSELEY RAILWAY CENTRE
670 Warwick Road, Tyseley, B11 2HL
www.tyseleylocoworks.co.uk
Vintage Trains: 01217 084960

WEST SOMERSET RAILWAY
Minehead Station, TA24 5BG
Williton Station, TA4 4RQ
Bishops Lydeard, TA4 3RU
www.westsomersetrailway.co.uk
Tel: 01643 704996

Other titles published by The History Press

Loco Motion

MICHAEL R. BAILEY

The steam locomotive is a machine that has inspired imagination, innovation and invention from the time of its origination and continues to evoke passion in enthusiasts today. Here Michael R. Bailey, expertly and in fascinating detail, describes the development of the steam locomotive during its pioneering first half-century until 1850 by exploring the surviving locomotives that may be seen in Britain, Europe, and North and South America. In addition to surviving relics, he also takes a look at operable replicas, which fill many gaps in international collections, to provide continuity in this evolutionary story. Exploring in depth each example's operational and preservation history, along with design characteristics, component materials and modifications made, no detail is left unmentioned. With unparalleled detail, incredibly stunning images and a list of museums housing all of the world's oldest locomotives, this truly is a volume that no student of railway history should be without.

978 0 7524 9101 1